Chromophobia

Chromophobia

DAVID BATCHELOR

REAKTION BOOKS

Published by Reaktion Books Ltd
Unit 32, Waterside
44–48 Wharf Road
London N1 7UX, UK

www.reaktionbooks.co.uk

First published 2000

Designed and typeset by Libanus Press
Printed and bound in India by Replika Press Pvt. Ltd

British Library Cataloguing in Publishing Data
Batchelor, David
 Chromophobia
 1. Color – Psychological aspects
 2. Color in art
 3. Art – Philosophy
 I. Title
 701.8' 5' 019

ISBN 978 1 86189 074 0

Contents

Whitescapes

Sometime one summer during the early 1990s, I was invited to a party. The host was an Anglo-American art collector, and the party was in the collector's house, which was in a city at the southern end of a northern European country. First impressions on arrival at this house: It was big (but then so were the houses around it, so it didn't appear *that* big). It was the kind of area – a wealthy area of a rich city – where only small or shabby things looked strange or out of place (like the solitary drunk I saw wrapped in an old yellowish-green overcoat). The house looked ordinary enough from the outside: red brick, nineteenth or early twentieth century, substantial but unostentatious. Inside was different. Inside seemed to have no connection with outside. Inside was, in one sense, inside-out, but I only realized that much later. At first, inside looked endless. Endless like an egg must look endless from the inside; endless because seamless, continuous, empty, uninterrupted. Or rather: uninterruptable. There is a difference. Uninterrupted might mean overlooked, passed by, inconspicuous, insignificant. Uninterruptable passes by *you*, renders *you* inconspicuous and insignificant. The uninterruptable, endless emptiness of this house was

impressive, elegant and glamorous in a spare and reductive kind of way, but it was also assertive, emphatic and ostentatious. This was assertive silence, emphatic blankness, the kind of ostentatious emptiness that only the very wealthy and the utterly sophisticated can afford. It was a strategic emptiness, but it was also *accusatory.*

Inside this house was a whole world, a very particular kind of world, a very clean, clear and orderly universe. But it was also a very paradoxical, inside-out world, a world where open was also closed, simplicity was also complication, and clarity was also confusion. It was a world that didn't readily admit the existence of other worlds. Or it did so grudgingly and resentfully, and absolutely without compassion. In particular, it was a world that would remind you, there and then, in an instant, of everything you were not, everything you had failed to become, everything you had not got around to doing, everything you might as well never bother to get around to doing because everything was made to seem somehow beyond reach, as when you look through the wrong end of a telescope. This wasn't just a first impression; it wasn't just the pulling back of the curtain to reveal the unexpected stage set, although there was that too, of course. This was longer-lasting. Inside was a flash that continued.

There is a kind of white that is more than white, and this was that kind of white. There is a kind of white that repels everything that is inferior to it, and that is almost everything. This was that kind of white. There is a kind of white that is not created by bleach but that itself is bleach. This was that kind of white. This white was aggressively white. It did its work on everything around it, and nothing escaped. Some would hold the architect responsible. He was a man, it is said, who put it about that his work was 'minimalist', that his mission was to strip bare and to make pure, architecturally speaking, that his spaces were 'very direct' and 'very clear', that in them there was 'no possibility of lying' because 'they are just what they are.' He was lying, of course, telling big white lies, but we will let that pass for the moment. Some would hold this man responsible

for the accusatory whiteness that was this great hollow interior, but I suspect that it was the other way around. I suspect that the whiteness was responsible for this architect and for his hollow words.

This great white interior was empty even when it was full, because most of what was in it didn't belong in it and would soon be purged from it. This was people, mainly, and what they brought with them. Inside this great white interior, few things looked settled, and even fewer looked *at home*, and those that did look settled also looked like they had been *prepared*: approved, trained, disciplined, marshalled. Those things that looked at home looked like they had already been purged from within. In a nutshell: those things that stayed had themselves been made either quite white, quite black or quite grey. This world was entirely purged of colour. All the walls, ceilings, floors and fittings were white, all the furniture was black and all the works of art were grey.

Not all whites are as tyrannical as this one was, and this one was less tyrannical than some: 'Is it that by its indefiniteness it shadows forth the heartless voids and immensities of the universe, and thus stabs us from behind with the thought of annihilation, when beholding the white depths of the milky way?'[1] Next to the white that was Herman Melville's great Albino Whale, this white paled. Next to the deathly, obsessive white that insinuated its way into the dark heart of Joseph Conrad's Captain Marlow, this white was almost innocent. Admittedly, there was some Conradian residue in this shallower white: 'Minimalism', it seemed to say, 'is something you arrive at, a development of the sensitivity of the brain. Civilization started with ornamentation. Look at all that bright colour. The minimalist sensitivity is not the peak of civilization, but it represents a high level between the earth and sky.' But this wasn't spoken with the voice of a Marlow; it contained no irony, no terror born of the recognition that whatever appeared before you now had always seen you before it a thousand times already. Rather, this was the voice of one of Conrad's Empire functionaries, one of those stiff, starched figures

whose certainties always protect them from, and thus always propel them remorselessly towards, the certain oblivion that lies just a page or two ahead.

What is it that motivates this fixation with white?

First of all, let's get the term *minimalism* and its careless association with whiteness out of the way. In reality, this didn't occur very often at all, at least in the Minimalism that consisted of three-dimensional works of art made during the 1960s, mostly in New York. Certainly, there are a good many skeletal white structures by Sol LeWitt. And Robert Morris was suspicious of colour, so he painted his early work grey, but not white. Dan Flavin used tubes of white light – or rather daylight, or cool white, which is to say whites, not white – but his work was more often than not made in pools of intermingling coloured light: red blue green yellow orange, and white. Carl Andre: intrinsic colours, the specific colours of specific materials – woods and metals in particular – no whites there to speak of. And Donald Judd: sometimes intrinsic colours, sometimes applied, some-times both together, sometimes shiny, sometimes transparent, sometimes polished, sometimes matt. Dozens of colours on dozens of surfaces, often in strange combinations: polished copper with shiny purple Plexiglas, or brushed aluminium with a glowing translucent red, or spray-painted enamels with galvanised steel, or whatever there was. In truth, the colours of Minimal art were often far closer to that of its exact contemporary, Pop art, than anything else. Which is to say: found colours, commercial colours, industrial colours, and often bright, vulgar, modern colours in bright, vulgar, modern collisions with other bright, vulgar, modern colours.

To mistake the colourful for the colourless or white is nothing new. But it is one thing not to know that Greek statues were once brilliantly painted; it is another thing not to see colour when it is still there. This seems to speak less of ignorance than of a kind of denial. Not perceiving what is visibly there: psychoanalysts call this negative hallucination. But we have to tread carefully here, and we should be especially careful not to

get drawn into seeing colour and white as opposites. White was sometimes used in Minimalism, but mostly as a colour and amongst many other colours. Sometimes, it was used alone, but even then it remained a colour; it did not result, except perhaps in LeWitt's structures, in a *generalized* whiteness. In these works, white remained a material quality, a specific colour on a specific surface, just as it always has done in the paintings of Robert Ryman. Ryman's whites are always just that: whites. His whites are colours; his paintings do not involve or imply the suppression of colour. His whites are empirical whites. Above all, his whites are plural. And, in being plural, they are therefore not 'pure'. Here is the problem: not white; not whites; but *generalized* white, because generalized white – whiteness – is abstract, detached and open to contamination by terms like 'pure'.

Pure white: this is certainly a Western problem, and there's no getting away from it. Conrad, who analyzed the Western problem better than most in his time and better than many in ours, could also recognize a white when he saw one. The imagery in *Heart of Darkness* is coloured almost exclusively in blacks and whites. This is not the same as the other great opposition in the narrative, that between darkness and light, although at times it comes close. Conrad's target is the generalization of whiteness and the predicates and prejudices that merge with the term and seem inseparable from it. This generalized whiteness forms a backdrop to the narrative, a bleached screen which is pierced and torn, time and again, by particular instances of white things. These things – white teeth, white hair, white bones, white collars, white marble, white ivory, white fog – always carry with them an uncanny sense of coldness, inertia and death. *White*, like *black*, like *light* and like *darkness*, becomes a highly complex term. For Conrad, to speak of white with certainty is, knowingly or otherwise, to be a hypocrite or a fool. Marlow recognizes this when he remarks that a certain European city 'always makes me think of a whited sepulchre'.[2] The intended reference here is to the Bible: 'Woe unto you, scribes and Pharisees, hypocrites! for ye are like unto whited sepulchres, which indeed

appear beautiful outward, but are within full of dead men's bones, and of all uncleanness. Even so ye appear outwardly righteous unto men, but within ye are full of hypocrisy and iniquity.'[3] Within the first few pages of the tale, long before Marlow has set off for Africa, his own whiteness already lies in ruins. It was something to be laid to rest, as he later puts it, in 'the dustbin of progress, amongst all the sweepings and all the dead cats of civilisation'.

There are only two short passages in *Heart of Darkness* where colour, or colours, are given any attention. One is close to the beginning of the story and one is close to the end, and they are oddly symmetrical. The former comes a few lines after Marlow arrives in the sepulchral city. He enters the Company's offices, 'arid as a desert', occupied by two women, one dressed 'plain as an umbrella-cover', one 'white haired', both knitting 'black wool'. Amid this grainy monochrome, his attention is caught by 'a large shining map, marked with all the colours of a rainbow', which he describes: 'There was a vast amount of red – good to see at any time, because one knows some real work is being done in there, a duce of a lot of blue, a little green, smears of orange, and, on the East coast, a purple patch, to show where the jolly pioneers of progress drink jolly lager-beer. However', he continues ominously, 'I wasn't going into any of these. I was going into the yellow.' These vivid hues are attractive, but they are also arbitrary. And their arbitrariness is ironic: they denote the 'white' territories, whereas the white areas on maps, which had fascinated Marlow as a child, marked unmapped or 'black' areas.

If this brightly coloured map marks a kind of gateway for Marlow to one heart of darkness, his second encounter with colour is also a kind of gateway to another dark heart: his encounter with Kurtz. As his steamer draws close to Kurtz's station, Marlow sees a man on the shore:

> He looked like a Harlequin. His clothes had been made of some
> stuff that was brown holland probably, but it was covered with

patches all over, with bright patches, blue, red, yellow, – patches on the back, patches on the front, patches on elbows, patches on knees; coloured binding around his jacket, scarlet edging at the bottom of his trousers; and the sunshine made him look extremely gay and wonderfully neat withal, because you could see how beautifully all this patching had been done.

This person, represented in Francis Ford Coppola's film *Apocalypse Now* by the crazed war photographer played by Dennis Hopper, talks incessantly and in contradictions; he has apparently travelled throughout the continent and has been both friend and enemy of Kurtz. After he departs, Marlow asks himself 'whether I had ever really seen him – whether it was possible to meet such a phenomenon!'

There is clearly a connection between these two passages. At its simplest, the patches that adorn the 'harlequin's' clothes could symbolize his erratic wandering through the various coloured patches that adorned the Company's map of Africa. But in both instances, colour is also given a kind of unreality; its arbitrariness consists of a kind of unconnectedness to anything; it is an addition or a supplement; it is artificial; it adorns. Or perhaps it is dislocated in a stronger and more dangerous sense. Either way, colour has a kind of autonomy from the unstable contradictions of black and white and the psychic confusions of darkness and light.

If Conrad punctures a generalized whiteness with numerous instances and examples of white things, Melville works in something like the opposite direction: he begins with one great big white thing and, at certain points, begins to wonder whether the terrible whiteness of this thing could be generalized beyond it and infect his more homely conception of white. 'It was the whiteness of the whale that above all things appalled me', he admits, while at the same time noting that 'in many natural objects, whiteness refiningly enhances beauty, as if imparting some special virtue of its own.' He recognizes the gravity of the impasse and his confusion:

'But how can I hope to explain myself here; and yet, in some dim, random way, explain myself I must, else all these chapters might be naught.' In the absence of an explanation, Melville, like many of us, compiles a list. His is a list of white things, in particular white creatures, which symbolize one or another kind of virtue: regal, imperial, religious, juridical, moral, communal, sexual . . . And yet, 'for all these accumulated associations, with whatever is sweet, and honourable, and sublime', Melville insists that there still 'lurks an elusive something in the innermost idea of this hue, which strikes more of panic to the soul than the redness which affrights in blood'. For Melville, as for Conrad, there is an instability in the apparent uniformity of white. Behind virtue lurks terror; beneath purity, annihilation or death. Not death in the sense of a life ended, but a glimpse of death-in-life: the annihilation of every cherished belief and system, every hope and desire, every known point of orientation, every illusion . . . For both writers, one of the most terrible instances of whiteness is a still, silent 'milk-white fog', which is 'more blinding than the night'. And for both, in the face of such whiteness, colour appears intolerably, almost insultingly, superficial. Melville:

> And when we consider that all other earthly hues – every stately or lovely emblazoning – the sweet tinges of sunset skies and woods; yea, and all the gilded velvet of butterflies, and the butterfly cheeks of young girls; all these are but subtle deceits, not actually inherent in substances, but only laid on from without; so that all defied Nature absolutely paints like a harlot, whose allurements cover nothing but the charnel-house within; and when we proceed further, and consider that the mystical cosmetic which produces every one of her hues, the great principal of light, for ever remains white or colourless in itself, and if operating without medium upon matter, would touch all objects, even tulips and roses, with its own blank tinge – pondering all this, the palsied

universe lies before us like a leper; and like wilful travellers in Lapland, who refuse to wear colored and coloring glasses upon their eyes, so the wretched infidel gazes himself blind at the monumental white shroud that wraps all the prospect around him.

For Melville, the truth of colour is merely cosmetic; it contains 'subtle deceits'; it is 'not actually inherent in substances'; it is only 'laid on from without'. But if nature 'paints like a harlot', it is not simply to seduce us, but to protect us in its seductions from 'the charnel-house within'. We have to wear tinted spectacles; otherwise, what we might see will make us blind.

The virtuous whiteness of the West also conceals other less mystical terrors. These are more local and altogether more palpable; they are, mainly, terrors of the flesh. Melville's great white whale is, conceivably, a monstrous corruption of the great Western ideal of the classical body. This body, at least in its remodelled neo-classical version, was of course a pure, polished, unembellished, untouched and untouchable white. For Walter Pater, writing on the neo-classical scholar Winkelmann and classical sculpture sometime between the publications of *Moby Dick* and *Heart of Darkness*, this 'white light, purged from the angry, bloodlike stains of action and passion, reveals, not what is accidental in man, but the tranquil godship in him, as opposed to the restless accidents of life'.[4] A few pages on, this light loses its whiteness and re-emerges as 'this colourless, unclassified purity of life' which is 'the highest expression of the indifference which lies beyond all that is relative and partial'. In his elision of whiteness with colourlessness, transparency and purity, Pater was at least following the logic of Winkelmann, for whom the ideal beauty of the classical form was 'like the purest water taken from the source of a spring . . . the less taste it has, the more healthy it is seen to be, because it is cleansed of all foreign elements'.[5] Winkelmann, in his turn, was following the example of Plato, for whom truth, embodied in the Idea, was, as Martin Jay has put it, 'like a visible form blanched of its colour'.[6]

It was this classical body, further purified and corrupted in Stalinist 'realism', that Mikhail Bakhtin counterposed with the altogether more fleshy and visceral 'grotesque realism' of the medieval body. For Bakhtin, the classical form was above all a self-contained unity,

> an entirely finished, completed, strictly limited body, which is shown from the outside as something individual. That which protrudes, bulges, sprouts, or branches off is eliminated, hidden or moderated. All orifices of the body are closed. The basis of the image is the individual, strictly limited mass, the impenetrable facade. The opaque surface of the body's 'valleys' acquires an essential meaning as the border of a closed individuality that does not merge with other bodies and with the world. All attributes of the unfinished world are carefully removed, as well as all signs of its inner life.[7]

Bakhtin's description of the classical body also describes with uncanny accuracy the art collector's 'minimalist' interior, where everything was finished, completed and strictly limited in a closed individuality that was not allowed to merge with the world outside. The idea that anything might protrude, bulge, sprout or branch off from this sheer whiteness was inconceivable. The inner life of this world was entirely hidden: nothing was allowed to spill out from its allotted space; all circuitry, all conduits, all the accumulated stuff that attaches itself to an everyday life remained concealed, held in, snapped shut. Every surface was a closed, impenetrable façade: cupboards were disguised as walls, there were no clues or handles or anything to distinguish one surface from another; just as there were no protrusions, neither was there a single visible aperture. In this way, openness really was an illusion maintained by closure, simplicity was ridiculously overcomplicated, and unadorned clarity was made hopelessly confusing. You really could become lost in this apparently blank and empty white space. In its need to differentiate itself from that which was

without, nothing could be differentiated within. This space was clearly a model for how a body ought to be: enclosed, contained, sealed. The ideal body: without flesh of any kind, old or young, beautiful or battered, scented or smelly; without movement, external or internal; without appetites. (That is why the kitchen was such a disturbing place – but not nearly as disturbing as the toilet.) But perhaps it was more perverse than that; perhaps this was a model of what the body should be like from *within*. Not a place of fluids, organs, muscles, tendons and bones all in a constant, precarious and living tension with each other, but a vacant, hollow, whited chamber, scraped clean, cleared of any evidence of the grotesque embarrassments of an actual life. No smells, no noises, no colour; no changing from one state to another and the uncertainty that comes with it; no exchanges with the outside world and the doubt and the dirt that goes with that; no eating, no drinking, no pissing, no shitting, no sucking, no fucking, no nothing.

It won't go away. Whiteness always returns. Whiteness is woven into the fabric of Culture. The Bible, again: 'Though your sins be as scarlet, they shall be as white as snow.'[8] We can't escape, but, as Conrad and Melville have shown, sometimes it is possible to unweave whiteness from within . . . Henri Michaux, artist, poet and acid-head, writing 'With Mescaline':

And 'white' appears. Absolute white. White beyond all whiteness. White of the coming of white. White without compromise, through exclusion, through total eradication of non-white. Insane, enraged white, screaming with whiteness. Fanatical, furious, riddling the victim. Horrible electric white, implacable, murderous. White in bursts of white. God of 'white'. No, not a god, a howler monkey. (Let's hope my cells don't blow apart.) End of white. I have the feeling that for a long time to come white is going to have something excessive for me.[9]

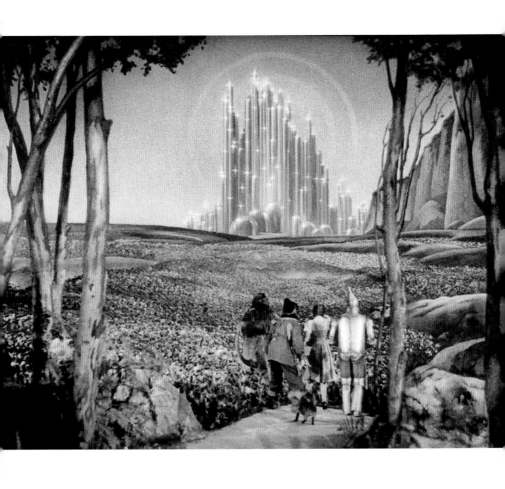

Chromophobia

If it started with a short visit to an inside-out interior of a colourless whiteness where clarity was confusion, simplicity was complication, and art was uniformly grey, then it would be comforting to think that it might also end there. After all, there can't be many places like this interior which was home only to the very few things that had submitted to its harsh regime. And those few things were, in effect, sealed off from the unwanted and uncertain contingencies of the world outside. No exchange, no seepage, no spillage. Rather: isolation, confinement. But this shutting-off began to speak more and more about what it excluded than what it contained. What did this great white hollow make me think about? Not, for long, its whiteness. Rather, its colour.

If colour is unimportant, I began to wonder, why is it so important to exclude it so forcefully? If colour doesn't matter, why does its abolition matter so much? In one sense, it doesn't matter, or it wouldn't if we could say for certain that this inside really was as self-contained and isolated as it looked. But this house was a very *ambitious* inside. It was not a retreat, it was not a monastic emptiness. Its 'voluntary poverty' – that's

how its architect likes to talk – was altogether more righteous and evangelical. It looked like it wanted to impose its order upon the disorder around it. Like neo-classicism, like the manifestos of Adolf Loos or Le Corbusier, it wanted to rescue a culture and lead it to salvation. In which case, colour does matter. It mattered to Melville and Conrad, and it mattered to Pater and Winkelmann; it mattered to Le Corbusier, and, it turns out, it has mattered to many others for whom, in one way or another, the fate of Western culture has mattered. It mattered because it got in the way. And it still matters because it still does.

The notion that colour is bound up with the fate of Western culture sounds odd, and not very likely. But this is what I want to argue: that colour has been the object of extreme prejudice in Western culture. For the most part, this prejudice has remained unchecked and passed unnoticed. And yet it is a prejudice that is so all-embracing and generalized that, at one time or another, it has enrolled just about every other prejudice in its service. If its object were a furry animal, it would be protected by international law. But its object is, it is said, almost nothing, even though it is at the same time a part of almost everything and exists almost everywhere. It is, I believe, no exaggeration to say that, in the West, since Antiquity, colour has been systematically marginalized, reviled, diminished and degraded. Generations of philosophers, artists, art historians and cultural theorists of one stripe or another have kept this prejudice alive, warm, fed and groomed. As with all prejudices, its manifest form, its loathing, masks a fear: a fear of contamination and corruption by something that is unknown or appears unknowable. This loathing of colour, this fear of corruption through colour, needs a name: chromophobia.

Chromophobia manifests itself in the many and varied attempts to purge colour from culture, to devalue colour, to diminish its significance, to deny its complexity. More specifically: this purging of colour is usually accomplished in one of two ways. In the first, colour is made out to be the property of some 'foreign' body – usually the feminine, the oriental,

the primitive, the infantile, the vulgar, the queer or the pathological. In the second, colour is relegated to the realm of the superficial, the supplementary, the inessential or the cosmetic. In one, colour is regarded as alien and therefore dangerous; in the other, it is perceived merely as a secondary quality of experience, and thus unworthy of serious consideration. Colour is dangerous, or it is trivial, or it is both. (It is typical of prejudices to conflate the sinister and the superficial.) Either way, colour is routinely excluded from the higher concerns of the Mind. It is other to the higher values of Western culture. Or perhaps culture is other to the higher values of colour. Or colour is the corruption of culture.

Here is a near-perfect example of textbook chromophobia: 'The union of design and colour is necessary to beget painting just as is the union of man and woman to beget mankind, but design must maintain its preponderance over colour. Otherwise painting speeds to its ruin: it will fall through colour just as mankind fell through Eve.'[1] This passage was written in the last decade of the nineteenth century by the appropriately named Charles Blanc, critic, colour theorist and sometime Director of the Arts in the 1848 Socialist government in France. It is interesting on a number of counts. Blanc identified colour with the 'feminine' in art; he asserted the need to subordinate colour to the 'masculine' discipline of design or drawing; he exhibited a reaction typical of phobics (a massive overvaluation of the power of that which he feared); and he said nothing particularly original. For Blanc, colour could not simply be ignored or dismissed; it was always there. It had to be contained and subordinated – like a woman. Colour was a permanent internal threat, an ever-present inner other which, if unleashed, would be the ruin of everything, the fall of culture. For our contemporary chromophobic architect, colour also represents a kind of ruination. Colour for him signifies the mythical savage state out of which civilization, the nobility of the human spirit, slowly, heroically, has lifted itself – but back into which it could always slide. For one, colour was coded in the feminine; for the other, it

is coded in the primitive. For both, colour is a corruption, a lapse, a Fall.

There are many different accounts of the fall into colour, and many of these – well, several, enough – take the shape of stories. This chapter is, for the most part, a story of a few of those stories.

There are many ways to fall: head first, feet first; like a leaf or a stone; on a banana skin or off a log; in a blaze of glory or in the darkness of despair. A fall can be trivial or dangerous; falls have a place of honour in comedy, in the circus, in tragedy and in melodrama. A fall may be biblical or farcical or, perhaps, both. Many of the different stories of the descent into colour are stories of a fall from grace. That is to say, they have roughly similar beginnings and ends; we know very generally where they are going to finish up. In that sense, they are not mysteries. But the manner and details of the falls are what's interesting: the terms used to describe the descent; the stages and locations; the twists and turns; the costumes and props; and, finally, the place where the falling stops, the place of colour.

Charles Blanc's *Grammaire des arts du dessin* (misleadingly translated into English as a *Grammar of Painting and Engraving*), published in 1867, is as good a place as any to begin, in part because his chromophobia is not quite as clear-cut as his Old Testament rhetoric at first suggests. Blanc was, for example, a supporter of Delacroix – 'one of the greatest colourists of modern times' – and was indebted to the colour theories of the chemist Eugène Chevreul, as well as to the principles of Newtonian optics. And yet, for all his commitment to an emerging 'science' of colour, his theory of painting is expressed in terms of an almost medieval cosmology, a cosmology in which colour has a very particular place. For Blanc, 'painting is the art of expressing all the conceptions of the soul, by means of all the realities of nature.'[2] That is to say, while painting uses nature, its real value lies beyond nature; it deals in 'conceptions of the soul'; it is a 'work of the mind'; it is always more than descriptive as the painter 'subordinates physical beauty to moral physiognomy . . .' At the centre of Blanc's moral universe of painting (more familiar then than now) is the 'idea' embodied

in human form; the expression of the moral truth of creation requires the 'correction' of the various accidents and contingencies of nature. Nevertheless, 'the artist will necessarily represent the human figure by its peculiar, even accidental characteristics,' and for this job painting 'will be the most fitting art, because it furnishes to expression immense resources, air, space, perspective, landscape, light and shadow, colour'. This list of painting's 'immense resources' was clearly not drawn up at random, and it is no accident that colour comes in at the end, after composition, drawing and chiaroscuro. Nevertheless, for Blanc 'colour in painting is an essential, almost indispensable element, since having all Nature to represent, the painter cannot make her speak without borrowing her language.' This is a strange image – colour as the language of nature – but it is crucial, as Blanc goes on to make clear:

Intelligent beings have a language represented by articulate sounds; organised beings, like all animals and vegetables, express themselves by cries or forms, contour or carriage. Inorganic nature has only the language of colour. It is by colour alone that a certain stone tells us it is a sapphire or an emerald . . . Colour, then, is the peculiar characteristic of the lower forms of nature, while drawing becomes the medium of expression, more and more dominant, the higher we rise in the scale of being.

Colour, then, is not only low down the hierarchy of a painter's skills and resources, as it had been in Academic training from the start; it is down there because that position corresponds to colour's lowly place in the moral hierarchy of the universe.

Later, in a substantial chapter devoted to colour, Blanc questions the idea, 'repeated everyday', that 'one learns to be a draughtsman but one is born a colourist.' Nothing could be further from the truth, he argues: the whole point about colour is that it is 'under fixed laws' and is fundamentally 'easier to learn than drawing'. Here Blanc could be

alluding to Chevreul's systematic research into colour-mixture or to Newton's earlier experiments with the prismatic division of light, or even to Goethe's experiments in colour psychology. But that is not how it comes across. Rather, it is God who allows us access to the laws of colour while, at the same time, keeping us guessing about the eternal laws of form:

> . . . the perfect form that is issued from the hand of God is unknown to us; remains always veiled from our eyes. It is not so with colour, and it would seem as if the eternal colourist had been less jealous of the secret than the eternal designer, for he has shown us the ideal of colour in the rainbow, in which we see, in sympathetic gradation, but also in mysterious promiscuity, the mother tints that engender the universal harmony of colours.

It is here, in the figure of the rainbow, that Blanc's creation theory meets modern colour theory, that God meets Newton. It is science that has allowed us to gain access to the mind of God, or at least to a small, relatively minor part of it, and through science, colour can be made finally to 'conform' to the higher requirements of the Idea.

Blanc had another problem with colour: the Chinese problem. He needed to prove that colouring was easier than drawing; that way, it didn't matter so much that 'oriental artists' were better colourists than Western ones. He conceded:

> From time immemorial the Chinese have known and fixed the laws of colour, and the tradition of those fixed laws, transmitted from generation to generation down to our own days, spread throughout Asia, and perpetuated itself so well that all oriental artists are infallible colourists, since we never find a false note in the web of their colours.

But, he continued, '. . . would this infallibility be possible if it were not engendered by certain and invariable principles?' – principles that

had been rationally analyzed in the West. Even now that colourists could 'charm us by means that science has discovered', one had to remain on guard, for

> the taste for colour, when it predominates absolutely, costs
> many sacrifices; often it turns the mind from its course, changes
> the sentiment, swallows up the thought. The impassioned
> colourist invents his form for his colour, everything is subordi-
> nated to the brilliancy of his tints. Not only the drawing bends
> to it, but the composition is dominated, restrained, forced by the
> colour. To introduce a tint that shall heighten another, a perhaps
> useless accessory is introduced . . . To reconcile contraries after
> having heightened them, to bring together similar after having
> lowered or broken them, he indulges in all sorts of licence, seeks
> pretexts for colour, introduces brilliant objects; furniture, bits
> of stuff, fragments of music, arms, carpets, vases, flights of steps,
> walls, animals with furs, birds of gaudy plumage; thus, little
> by little, the lower strata of nature take the first place instead
> of human beings which alone ought to occupy the pinnacle of
> art, because they alone represent the loftiest expression of life,
> which is thought.

And where does that leave us? Fallen. From a lofty place tantalizingly close to God, we have fallen down flights of steps, past furry animals and gaudy birds, through a tangle of stuff and oriental knick-knacks – 'cushions, slippers, narghilehs, turbans, burnous, caftans, mats, parasols' – and ended up face down among the lower forms of nature.

For Blanc, there were only two ways to avoid the Fall: abandoning colour altogether or *controlling it*. Both had their risks. He is a little vague about the first option; at times, colour is 'essential' to painting, but in the same breath it might be only 'almost indispensable'. Elsewhere, he convinces himself that 'painters can sometimes dispense with colour,'

yet a little later on it is reinstated: 'Colour being that which especially distinguishes painting from the other arts, it is indispensable to the painter.' Blanc appears to have been genuinely uncertain about colour; it shifts from being essential to being dispensable, from being low in the order of nature and representation to being the very essence and uniqueness of painting as an art. But for the most part, Blanc accepted that colour cannot be willed away; the job therefore is to master it by learning its laws and harnessing its unpredictable power: '. . . let the colourist choose in the harmonies of colour those that seem to *conform to his thought*.'

Conform, subordinate, control: we are back with Adam and Eve, back in a universe populated entirely by unequal opposites: male and female, mind and heart, reason and emotion, order and disorder, absolute and relative, structure and appearance, depth and surface, high and low, occident and orient, line and colour . . . For example: 'Here we recognise the power of colour, and that its role is to tell us what agitates the heart, while drawing shows us what passes in the mind, a new proof . . . that drawing is the masculine side of art, colour the feminine side.' Or: 'As sentiment is multiple, while reason is one, so colour is a mobile, vague, intangible element, while form, on the contrary, is precise, limited, palpable and constant.' Or: '. . . colour, which speaks to the senses rather than to the mind' is 'more external, hence, more secondary'. Or: 'There is . . . in painting, an essential element which does not readily lend itself to emblematic expressions – that is, colour . . . the artist using colour will particularise what he seeks to generalise, and he will contradict his own grandeur.' Or: 'The predominance of colour at the expense of drawing is a usurpation of the relative over the absolute, of fleeting appearance over permanent form, of physical impression over the empire of the soul.'

Blanc inherited these opposites from an intimidating and ancient tradition of *disegno versus colore*: drawing versus colouring-in. When, in the art room at primary school, I was told to take a line for a walk and

then colour it in, I certainly wasn't told that the line I was being asked to draw was in fact the continuation of a much longer one which could be followed almost without interruption back to the philosophical art rooms of ancient Greece. Nor was I told that within this apparently harmless opposition between line and colour, many other oppositions were in fact coded and concealed, all of them far from innocent. As Jacqueline Lichtenstein shows in her brilliant study of painting and rhetoric, *The Eloquence of Color*, evidence of chromophobia in the West can be found as far back as Aristotle, for whom the suppression of colour was the price to be paid for bailing art out from a more general Platonic iconophobia. For Aristotle, the repository of thought in art was line. The rest was ornament, or worse. In his *Poetics*, he wrote: '. . . a random distribution of the most attractive colours would never yield as much pleasure as a definite image without colour.'[3] It is from here that we inherited a hierarchical ordering within painting which in its polished form describes a descent from 'invention' through 'design' to 'chiaroscuro' and, finally, to 'colour'. But hang on a minute. Since when was 'random' associated with colour and 'definite' with drawing? Since when did drawing and colour become ciphers for order and chaos? Perhaps it doesn't matter: the prejudice is in place.

Since Aristotle's time, the discrimination against colour has taken a number of forms, some technical, some moral, some racial, some sexual, some social. As John Gage notes in his vast historical survey of colour theory, colour has regularly been linked with other better-documented sexual and racial phobias. As far back as Pliny, it was placed at the 'wrong' end of the opposition between the occidental and the oriental, the Attic and the Asian, in a belief that 'the rational traditions of western culture were under threat from insidious non-western sensuality.'[4] In later times, the Academies of the West continued and consolidated this opposition. For Kant, colour could never participate in the grand schemes of the Beautiful or the Sublime. It was at best 'agreeable' and could add 'charm'

to a work of art, but it could not have any real bearing on aesthetic judgement. In a similar vein, Rousseau maintained that:

> colours, nicely modulated, give the eye pleasure, but that pleasure is purely sensory. It is the drawing, the imitation that endows these colours with life and soul, it is the passions which they express that succeed in arousing our own, the objects which they represent that succeed in affecting us. Interest and sentiment do not depend on colours; the lines of a touching painting touch us in etching as well: remove them from the painting, and the colours will cease to have any effect.[5]

Likewise, Joshua Reynolds, founder of the Royal Academy:

> Though it might be allowed that elaborate harmony of colouring, a brilliancy of tints, a soft and gradual transition from one to another, present to the eye, what a harmonious concert of musick does to the ear, it must be remembered, that painting is not merely a gratification of the sight. Such excellence, though properly cultivated, where nothing higher than elegance is intended, is weak and unworthy of regard, when the work aspires to grandeur and subliminity.[6]

Or Bernard Berenson, English aesthete and classicist: 'It appears . . . as if form was the expression of a society where vitality and energy were severely controlled by mind, and as if colour was indulged in by communities where brain was subordinated to muscle. If these suppositions are true', he added with heavy irony, 'we may cherish the hope that a marvellous outburst of colour is ahead of us.'[7]

So it hadn't ended when many of the Academies collapsed under their own weight during the later nineteenth century. To this day, there remains a belief, often unspoken perhaps but equally often unquestioned, that seriousness in art and culture is a black-and-white issue, that depth

is measured only in shades of grey. Forms of chromophobia persist in a diverse range of art from more recent years – in varieties of Realism, for instance, with its unnatural fondness for brown, or in Conceptual art, which often made a fetish of black and white. And it is in much art criticism, the authors of which seem able to maintain an unbroken vow of silence on the subject of colour even when it is quite literally staring them in the face. Likewise, when Hollywood discovered colour, it was deemed suitable mainly for fantasies, musicals and period pieces; drama remained a largely monochrome issue. Then there is the question of architecture, which we have already touched upon. But this is to get ahead of the story . . .

One thing that becomes clear from Blanc's thesis is that colour is both secondary *and* dangerous; in fact, it is dangerous because it is secondary. Otherwise there would be no Fall. The minor is always the undoing of the major.

Where do we find the idea of the Fall in contemporary culture? One answer would be in the image of drugs – or drug culture – and the moral panic that surrounds it. The fall-from-grace-that-is-drugs is often represented in a way that is not unlike the descent into colour described by Blanc. Sensuous, intoxicating, unstable, impermanent; loss of control, loss of focus, loss of self . . . Now it turns out that there is a rather interesting relationship between drugs and colour, and it is not a recent invention. Rather, it too goes back to Antiquity, to Aristotle, who called colour a drug – *pharmakon* – and, before that, to the iconoclast Plato, for whom a painter was merely 'a grinder and mixer of multi-colour drugs'.[8] The best part of two and a half millennia later, it appears that little has changed. During the 1960s, for example, drugs were commonly, and sometimes comically, associated not just with the distortion of form but with the intensification of colour. Think of those films – *Easy Rider* is the most obvious example – that attempted to convey the effects of dropping acid. Think of psychedelia; think of the album covers, the posters,

the lyrics; think, for example, of the Rolling Stones' *Her Satanic Majesty's Request* and of the song 'She Comes in Colours' (recently revived to advertise the hippy trippy brightly coloured iMac computers . . .). Today, the connection between colour and drugs seems a bit looser. Damien Hirst's *Spot Paintings* make at least a nominal connection between the two – if you accept his suggestion that their evenly spaced circles of colour can be read as schematic images of pharmaceutical pills.

There is a more interesting, if less plausible, semantic connection between colour and drugs. Ecstasy, as everyone knows, is the name given to a widely used psychotropic stimulant, but it is also a synonym for Roland Barthes' remarkable description of colour as 'a kind of bliss'. Bliss, *jouissance*, ecstasy. Barthes goes on: 'Colour . . . is a kind of bliss . . . like a closing eyelid, a tiny fainting spell.'[9] A tiny fainting spell: a lapse, a descent, a Fall. Intoxication, loss of consciousness, loss of self. But here something else has happened: Barthes has given colour the same trajectory as Blanc did, and, like Blanc, he has overtly eroticized colour. Also like Blanc, he has given colour the power to overwhelm and annihilate. At the same time, however, he has also inverted Blanc's Old Testament foreboding. In Barthes' hands, chromophobia is turned into its opposite: a kind of chromophilia.

This turn, this description of colour as falling *into* a state of grace or something approaching it, is characteristic of other writing both on colour and about drugs. In *The Doors of Perception*, Aldous Huxley describes in detail the experience of taking mescaline. The first and most emphatic change he registers is in his experience of colour: 'Half an hour after swallowing the drug I became aware of a slow dance of golden lights. A little later there were sumptuous red surfaces swelling and expanding from bright nodes of energy that vibrated with a continuously changing, patterned life . . .'[10] Looking around his study, his attention is held by a small vase containing three flowers, then by the books lining the walls:

Like the flowers . . . [the books] glowed, when I looked at them, with brighter colours, a profounder significance. Red books, like rubies; emerald books; books bound in white jade; books of agate, of aquamarine, of yellow topaz; lapis lazuli books whose colour was so intense, so intrinsically meaningful, that they seemed to be on the point of leaving the shelves to thrust themselves more insistently on my attention.

A little later, he notices an old chair in the garden: 'That chair . . . Where the shadows fell on the canvas upholstery, stripes of a deep but glowing indigo alternated with stripes of an incandescence so intensely bright that it was hard to believe that they could be made of anything but blue fire . . .' The flood of colour that Huxley describes becomes the basis for his speculations regarding the qualities of mescaline-coated consciousness. The transformation of everyday objects leads him at one point to note that 'today the percept had swallowed the concept.' Today, that is, was seeing rather than seeing-as, seeing as-if-for-the-first-time, the recovery of a lost innocence: 'I was seeing what Adam had seen on the morning of his creation – the miracle, moment by moment of naked existence.' Today, 'Visual impressions are greatly intensified and the eye recovers some of the perceptual innocence of childhood, when the sensum was not immediately and automatically subordinated to the concept . . .'

Adam was innocent. But the idea of innocence offered by Huxley would have been incomprehensible to Blanc, for whom Adam was, it seems, already imbued with the Idea; he was, at least in some sense, already rational, coherent, the image of the Father. His innocence, his purity, was, well, different. Huxley's Adam is innocent of concepts, innocent of self, and thus is open to the unmediated flow of perception: he is immersed in colour which is Eden. 'Mescaline', Huxley notes, 'raises all colours to a higher power and makes the percipient aware of innumerable fine shades of difference, to which, at ordinary times, he is completely blind.'

Its effect – its value – lies in its reversal of the order of things, the conventional hierarchies of thought:

> It would seem that, for Mind at Large, the so-called secondary
> character of things is primary. Unlike Locke, it evidently feels
> that colours are more important, better worth attending to than
> masses, positions and dimensions. Like mescaline takers, many
> mystics perceive supernaturally brilliant colours, not only with
> the inward eye, but even in the objective world around them.

To take mescaline is to be caught in the intense gaze of colour as much as it is to gaze at a new-found intensity of colour. To be transfixed by the radiant glow of 'books like rubies, emerald books' – the same precious stones which, for Blanc, were the mute lower forms of nature – is, for Huxley, to be exulted, to achieve a state of grace, a state of Not-self.

The Not-self is other; the other is colour. Another example: the poet Joachim Gasquet reporting some remarks made by Cézanne about looking at painting:

> Shut your eyes, wait, think of nothing. Now, open them . . . One
> sees nothing but a great coloured undulation. What then? An
> irradiation and glory of colour. This is what a picture should
> give us . . . an abyss in which the eye is lost, a secret germination,
> a coloured state of grace . . . Lose consciousness. Descend with
> the painter into the dim tangled roots of things, and rise again
> from them in colours, be steeped in the light of them.[11]

An abyss; disorientation; loss of consciousness; descent. And resurrection; grace. (It is not entirely surprising that this passage was quoted by the psychoanalyst Marion Milner, for whom 'the dark possibilities of colour' were counterposed to the 'white light of consciousness'.) Cézanne's descent was also undertaken in the name of innocence, and in some respects his conception of colour is not so different from Huxley's. 'See

like a man who has just been born', the artist is reported to have said.[12] Cézanne, it has been argued, subscribed to the idea that a new-born child lives in a world of naïve vision where sensations are unmediated and uncorrupted by the 'veil of . . . interpretation'. The work of the painter was to observe nature as it was beneath this veil, to imagine the world as it was before it had been converted into a network of concepts and objects. This world, for Cézanne, was 'patches of colour'; thus 'to paint is to register one's sensations of colour.'

Eyes closed, drugged, unconscious: the rush of colour is also a drift into a dream state. Gustave Moreau: 'Note one thing well: you must think through colour, have imagination in it. If you don't have imagination, your colour will never be beautiful. Colour must be thought, imagined, dreamed . . .'[13] Baudelaire: 'Just as a dream inhabits its own proper atmosphere, so a conception, become composition, needs to have its being in a setting of colour peculiar to itself.'[14] Elsewhere, Baudelaire condemns those artists and critics for whom 'colour has no power to dream.' In his essay on the work of Delacroix, he cites a remark made by Liszt about the painter's love of Chopin's music: 'Delacroix . . . says that he loved to fall into deep reverie at the sound of that delicate and passionate music, which evokes a brightly coloured bird, hovering over the horrors of a bottomless pit.' It isn't hard to see why the image would have been so compelling to Baudelaire: the gentle fall into dream is brought on by the delicate passion of music; the music itself is a brightly coloured bird. The unexpected turn at the end of the image is what gives it its unique power. At the same time as the music heralds a fall into unconsciousness, it also holds off another, far greater fall, always present and never out of sight: the fall into a bottomless pit of unnameable horror. Music, colour, colour-music, the colours of Delacroix's painting – these are certainly 'enchanting', but they are also much more than that. They offer salvation from and simultaneously make us aware of the presence of unutterable terror. Such works may induce a state of grace, but this

state is always fragile and vulnerable. The dream is always on the edge of nightmare.

The theme of colour as a fall from grace – or a fall into grace – can be updated a little. For example: Wim Wenders's 1986–7 film *Wings of Desire*, in which the viewer is taken to and fro between two worlds: the realm of the spirits and angels, and the sensuous world of embodied beings. We know where we are only because the latter is shown in full colour, but the spirit world is shown in black and white. When the angel (played by Bruno Ganz) falls to earth as the result of another fall – into love – he lands with a thud. Dazed and amazed, he looks around the Berlin wasteland into which he has dropped. He feels a small cut on the back of his head and looks at the blood left on his hand. He approaches a passer-by:

'Is this red?'

'Yes.'

'And the pipes?'

'They're yellow.'

'And him there?' [pointing at some painted figures on the Berlin Wall]

'He's grey-blue.'

'Him?'

'He's orange . . . ochre.'

'Orange or ochre?'

'Ochre.'

'Red . . . Yellow . . . And him?'

'He's green.'

'And the bit above the eyes?'

'That's blue.'

The first questions the angel asks are the names of the colours he sees. His fall from grace is a fall into colour, with a thud. It is a fall from the disembodied all-observing spirit world into the world of the particular and the contingent, a world of sensuous existence, of hot and cold, of taste

and touch, but most of all it is a fall into a world of desire. It is a fall into a world of consciousness and self, or rather a fall from super-consciousness into individual consciousness, but it is a fall into self made with the explicit purpose of losing the self in desire.

There are other cinematic descents into colour from the dubious stability of black and white – among them Michael Powell's World War II fable *A Matter of Life and Death*, on which *Wings of Desire* was more than loosely based. Here, the world of spirits is again represented exclusively in black and white. 'We are starved of Technicolor up here' says a very camp French angel, half to the camera. But in this movie it is a man, not an angel – albeit a man with wings: a pilot – who falls to earth, and he falls not from a monochrome heaven but from a lurid, blazing hell in the shape of a disintegrating Lancaster bomber. He (David Niven) falls to earth but does not die, and he cheats death because he too has fallen in love. He falls from colour into colour, but this is different: the sky was night, fury and death; earth is clear sky, sunlight and warmth. Earth is good; earth is life and love, green hills and blue skies; earth is . . . England.

The colour world of England is not the same as that of Berlin, which is more harsh and uncertain and altogether less homely. England was at war (though it hardly showed); Berlin was at war with itself and its memories. These differences are contained in the colours and monochromes of the films, and in the transitions between the two. Sam Fuller's 1963 *Shock Corridor* also uses occasional colour scenes within an otherwise black-and-white film to represent a kind of internalized war. The film is an allegory of the psychoses lying beneath the surface of American postwar culture. The world is black and white. Colour occurs not as an angel or a man falls from the exulted (if bureaucratic and rather boring) world of the spirits into the palpable world of flesh and blood and love, but as patients in a secure mental institution lapse into delirium. The three short colour episodes in the film denote different psychotic episodes, points at which the patients suffer a loss of self. In the first, a deranged Korean War veteran – deranged

because he was brainwashed by the 'Commies' and couldn't deal with the harsh reality of Cold War America – relives his trauma in a series of grainy, colour-saturated home-movie glimpses of everyday life in Japan and South Korea. In the second, a young African-American man – unable to cope with the pressures and publicity of having been the first black person to enter a Southern university, and now living a fantasy life as a rabid Klansman – experiences his delirium through coloured ethnographic footage of an Amazonian tribal dance. In each of these episodes of stark otherness, the suddenness of the transition into colour comes as a shock; but while colour signifies the otherness of psychosis, the colour footage is footage of other cultures: South-east Asia and South America. The third colour episode concerns the main character in the film, an ambitious journalist who fakes mental illness to get admitted to the institution in order to investigate a murder. As he snoops around, he encounters the various allegorical in-patients and, little by little, begins to lose his own grip. Then, during a heavy storm, he loses it entirely. And he falls: first of all into an interior mental deluge, then into a colour deluge made up of random close-ups of teeming rapids and waterfalls. It's an extraordinary and disturbing scene. Although the colour section lasts no more than fifteen or twenty seconds, the combination of the imagery's force and unexpected-ness is quite startling. The world of psychosis and that of colour are both and at once immensely powerful and entirely formless. They have no shape. They cannot be grasped or contained. They are terror.

And then there is *Ivan the Terrible*, Sergei Eisenstein's unfinished trilogy about the unification of Russia under Tsar Ivan. In *The Boyars' Plot*, the second of the two completed parts, most of the action takes place in the shadowy labyrinthine chambers of some medieval castle. As Ivan seeks to both unify Russia and consolidate his rule, just about everyone around him appears to be seeking the exact opposite. The atmosphere of treachery, conspiracy and paranoia is etched in a thin grey light and long black shadows. Until, that is, a great feast is organized by Ivan. At this

point, the film turns to livid reds and golds as the guests (which include most of the Tsar's enemies) drink, dance, sing and fall over. It is a moment of excess, intoxication and masquerade, and it is saturated with colour. As the party ends and the crowd moves to the cathedral to become a congregation, the colour is left behind. The conspirators' plot is exposed, and Ivan consolidates his power base. The final scene shows him on his throne: secure, intense and Terrible. And the colour returns.

There are several less terrifying falls into colour in the movies, although in these too, colour for the most part remains beyond the orderly and the rational, and thus remains dangerous and disruptive. There is, for example, the recent *Pleasantville*, about two full-colour American '90s teenagers sucked into a monochrome '50s sitcom. But one film stands out from all the others: the extraordinary, wonderful *The Wizard of Oz*. Made in 1939, this movie's great set piece is a spectacular descent into brilliant Technicolor. Having been scooped up by the tornado, Dorothy's house, together with Dorothy herself (Judy Garland) and Toto, falls out of the sky into Munchkinland, a fall that has a direct impact on the narrative and an especially direct impact on the Wicked Witch of the East. Dorothy's own drift into colour is, as I was devastated to discover when I first saw the film, revealed to be 'only' a dream-state, a result of her fall into unconsciousness. So Dorothy falls, twice. And she does so in a way that Baudelaire, Cézanne and Barthes would have understood. As she lands, she is greeted by the saccharine Glinda, aka the Good Witch of the North, who instructs the Munchkins to:

> . . . meet the young lady who fell from a star.
> She fell from the sky,
> She fell very far,
> And Kansas she says is the name of the star . . .
> When she fell out of Kansas,
> A miracle occurred.

Dorothy falls, and also finds herself among Charles Blanc's lower strata of nature: the Emerald City, the Yellow Brick Road and, of course, the Ruby Slippers. And there is talk of a rainbow (but not of God or Newton). Then there is the Horse of a Different Colour You've Heard Tell About. 'Toto, I have a feeling we are not in Kansas anymore', says Dorothy, observantly, to her dog. No, Kansas was *grey*, so grey that it was ur-grey. As Salman Rushdie notes in his unapologetically Totophobic account of the film and L. Frank Baum's book,

> . . . everything is grey as far as the eye can see – the prairie is grey and so is the house in which Dorothy lives. As for Auntie Em and Uncle Henry: 'The sun and the wind . . . had taken the sparkle from her eyes and left them a sober grey; they had taken the red from her cheeks and lips, and they were grey also. She was thin and gaunt, and never smiled now.' Whereas 'Uncle Henry never laughed. He was grey also, from his long beard to his rough boots.' The sky? It was 'even greyer than usual'.[15]

And when Dorothy's release from greyness arrives, it is itself a maelstrom of grey: 'It is out of this greyness – the gathering, cumulative greyness of that bleak world – that calamity comes. The tornado is the greyness gathered together and whirled about and unleashed, so to speak, against itself.'

For Rushdie, we are not so much caught up in a Fall as in an uprooting and displacement into colour. Within the yearning in Judy Garland's voice

> is the human dream of *leaving*, a dream at least as powerful as its countervailing dream of roots. At the heart of *The Wizard of Oz* is a great tension between these two dreams . . . In its most potent emotional moment, this is unarguably a film about the joys of going away, of leaving the greyness and entering the colour, of making a new life in the 'place where there isn't any trouble'. 'Over the Rainbow' is, or ought to be, the anthem of all

the world's migrants, all those who go in search of the place where 'the dreams that you dare to dream really do come true'. It is a celebration of Escape, a great paean to the Uprooted Self, a hymn – the hymn – to elsewhere.

Falling or leaving: these two metaphors of colour are closely related. Their terminologies – of dreams, of joys, of uprootings or undoings of self – remain more or less the same. More than that, perhaps, the descent into colour often involves lateral as well as vertical displacement; it means being blown sideways at the same time as falling downwards. After all, Blanc's 'impassioned colourist' falls from the rational Academies of the West into the market stalls and bestiaries of the East, and numerous other accounts, chromophobic and chromophilic alike, describe something similar. In the end, Dorothy has to return from colour – to Home, Family, Childhood, Kansas and Grey. 'East, West, Home is Best.' So she chants (in the book), albeit without a chance of convincing anyone who has taken a moment to compare the land of Oz with the grey-on-grey of Kansas, as Rushdie points out. Perhaps the implications of not returning, of not recovering from the Fall into colour, were too radical for Hollywood to contemplate.

And not just for Hollywood. There is a curious parallel between the dream-journey of Dorothy and travels described by Charles-Edouard Jeanneret, aka the architect Le Corbusier, in his *Journey to the East*. Coming from the man who would later say that colour was 'suited to simple races, peasants and savages', it's surprising to find that his first published writing is in fact an ecstatic, intoxicated, confusing, delirious, sensuous plunge into colour. Written in 1911 as a series of newspaper articles and only published in 1965 as *Le Voyage d'Orient*, this is a story of leaving and of entering colour, a story of returning and a story told as if it were a dream.

Near the beginning of the narrative, Le Corbusier describes in passing a journey by boat which is vaguely reminiscent in its monochromatic

starkness of Conrad's journey down the Thames: 'The great white boat had left Budapest at nightfall. Helped by the strong current, it made its way down the immense watercourse that marked out with a black path to the right and the left the two distant riverbanks . . .'[16] This imagery makes the traveller's entry into colour all the more dramatic. Once in his Orient, almost every description becomes tinted; almost every observation becomes a poem to colour. Sometimes, this appears quite innocent: 'There is in the sky, before the night hardens things, a watershed of emerald green and indigo blue.' But more often, in the intense daylight, the descriptions of colours, objects, architecture and people begin to blur, spill or dissolve into each other as if their limits had been lost in a haze of sexual intensity:

> You recognise these joys: to feel the generous belly of a vase, to caress its slender neck, and then to explore the subtleties of its contours. To thrust your hands into the deepest part of your pockets and, with eyes half closed, to give way to the slow intoxication of the fantastic glazes, the bursts of yellows, the velvet tones of the blues . . .

A little later on: 'Everything is smothered in flowers, and under these ephemeral bouquets, other ephemeral bouquets . . . young girls, beautiful women, smiling, somewhat depraved, perhaps a little inflamed by their desires. Gentlemen in black play second fiddle in this orchestra of colours . . .' For Le Corbusier, the Orient becomes an 'explosion of colours', and inevitably 'The eye becomes confused, a little perturbed by this kaleidoscopic cinema where dance the most dizzying combinations of colours.' His preferred description for this undifferentiated assault on the senses is a dreamy 'intoxication': 'The colour . . . exists for the caress and intoxication of the eye'; 'the intoxicating embrace of the moist evening, wafting voluptuously from the mountainside'; 'in the drowsiness of everything, in the vague intoxication of feeling space collapse and expand', You are left helpless: 'You are intoxicated; you cannot react at all.'

Once again, the drug of colour begins to weigh heavily on our eyes; we become drowsy; we begin to lose consciousness as we fall under its narcotic spell; we lose focus; we lose our sense of the distinctions between things; we descend into delirium; we lose ourselves in colour as colour frees itself from the grip of objects and floods over our scrambled senses; we drown in the sexual heat of colour . . . And the Technicolor dream continues:

The exterior is as red as iron reaching melting point. There it is, swollen, supple, and so close to the earth on its level shoreline, its pleasing oval forms radiant with clarity like an Egyptian alabaster urn carrying a burning lamp. The urn is strangely protective this evening, as if in mystical abandon outright gifts are torn away from living flesh and offered in painful and bloody oblations to the Beyond, to the Other, to Whomever, to any Other than the self. The overwhelming delirium of this moment and place.

We have no sense of direction. We drift. Hallucination follows hallucination. We are in confusion: '. . . we others from the centre of civilisation, are savages . . .' And then, as if by chance – although chance has no particular meaning in our dreamwork – we discover a destination, an awakening, a recovery which puts our dream into an envelope of rationality, like it did for poor Dorothy. But unlike Dorothy's, Le Corbusier's awakening occurs *within* the dream. His dream-awakening dream is the Acropolis: 'To see the Acropolis is a dream one treasures without even dreaming to realise it.' Yet, realized, this dream is no less a dream. Stuck in Athens for weeks because of a cholera outbreak, Le Corbusier reflects: 'Days and weeks passed in this dream and nightmare, in a bright morning, through an intoxicating noon, until evening . . .' He is entranced, captive to its absolute spell: 'Nothing existed but the temple;' it was 'an ineluctable presence'; 'the Parthenon, the undeniable Master'; 'Admiration, adoration, and then annihilation'.

Annihilation? Of what? There could be several answers to this. On

the one hand, Le Corbusier is surrounded by a cholera epidemic; he sees the dead being taken from their houses; perhaps he sees his own death in the dead around him. But I suspect he had a bigger death in mind: self-annihilation in the face of the incomprehensible sublime force that was the Acropolis, and with it the annihilation of all that came before this overwhelming experience: annihilation of the Orient and everything that was the dream-journey that preceded and led to this moment of revelation; annihilation of confusion; annihilation, perhaps, of desire. For once he had seen the Acropolis, Le Corbusier immediately decided that he had no further need of the East; the rest of his journey (not described in the book) would be through Italy and back to France: 'I will see neither the Mosque of Omar nor the pyramids. And yet I write with eyes that have seen the Acropolis, and I will leave with joy. Oh! Light! Marbles! Monochromy!'

East, West, Home is Best.

What colour was the Parthenon in Le Corbusier's dream? Not, as one might expect from his later writings, a magnificent, triumphant, all-embracing white. Or not immediately. Rather, in his description of the great temple, next to the form, volume, mass and space of the architecture, colour begins to *give way*; colour no longer appears to be such a significant force; it no longer has the same power to intoxicate; it no longer has quite the same intensity. His description becomes more muted: 'I shall give this entire account an ochre cast;' the marbles adopt the colour of the landscape and 'seem as reddish-brown as terra-cotta'. And yet in this *reflected* colour, there is still something awesome: 'Never in my life have I experienced the subtleties of such monochromy.' Only later, during a storm, does the Parthenon whiten: 'I saw through the large drops of rain the hill becoming suddenly white and the temple sparkle like a diadem against the ink-black Hymettus and the Pentilicus ravaged by downpours.' Once again, the Parthenon absorbs and reflects the colours of its surroundings and atmosphere, but it does not seem to have colour of its own; the Parthenon is somehow beyond colour.

In Le Corbusier's earlier evocations, just about every object had brilliant local colour, and these intense hues were often intermingled with strong blacks and dazzling whites. White was the precondition for colour; colour was intensified by its proximity to white; there was no sense of opposition between the two; they were co-dependent and co-operative. That was certainly part of the brilliance of Le Corbusier's early writing on colour. The *separation* of whiteness and colour would come later. Le Corbusier in 1925 in *The Decorative Art of Today*:

> What shimmering silks, what fancy, glittering marbles, what opulent bronzes and golds! What fashionable blacks, what striking vermilions, what silver lamés from Byzantium and the Orient! Enough. Such stuff founders in a narcotic haze. Let's have done with it . . . It is time to crusade for whitewash and Diogenes.[17]

The architect was done with drugs. He had been off them since at least 1920; the Great War had seen to that. In their place: Order. Reason. Purity. Truth. Architecture. Whitewash.

In his evangelical *Rappel à l'ordre* tirade against 'the flourish, the stain, the distracting din of colours and ornaments', and in his campaign for a world shaped by the New Spirit and a new architecture, Le Corbusier aligned himself with the earlier but equally evangelical Adolf Loos: 'We have gone beyond ornament, we have achieved plain, undecorated simplicity. Behold, the time is at hand, fulfilment awaits us. Soon the streets of the city will shine like white walls! Like Zion, the Holy City, Heaven's capital. The fulfilment will be ours.'[18] Heaven is white; that which gets closest to God – the Parthenon, the Idea, Purity, Cleanliness – also sheds its colour. But for Le Corbusier, ornament, clutter, glitter and colour were not so much signs of primitive 'degeneracy', as they had been for Loos, as they were the particularly modern form of degeneration that we now call kitsch. The difference is important, because at no time did Le Corbusier

attack what he saw as the authentic 'simplicity' of the folk cultures of the past, cultures which, he conceded, had their own whiteness: 'Whitewash has been associated with human habitation since the birth of mankind.' The problem was, rather, modern industrialized ornamentation and colouring, a problem which, for Le Corbusier, reeked of confusion, disorder, dishonesty, imbalance, subservience, narcosis and dirt.

Thus, under the chapter title 'A Coat of Whitewash: The Law of Ripolin' (a phrase that is constantly repeated and usually capitalized):

> we would perform a moral act: *to love purity*!
> we would improve our condition: *to have the power of judgement*!
> An act which leads to the joy of life: the pursuit of perfection.
> Imagine the results of the Law of Ripolin. Every citizen is required to replace his hangings, his damasks, his wall-papers, his stencils, with a plain coat of white ripolin. *His home* is made clean. There are no more dirty, dark corners. *Everything is shown as it is*. Then comes *inner* cleanness, for the course adopted leads to refusal to allow anything which is not correct, authorised, intended, desired, thought-out: no action before thought. When you are surrounded with shadows and dark corners you are at home only as far as the hazy edges of the darkness your eyes cannot penetrate. You are not master in your own house. Once you have put ripolin on your walls you will be *master of your own house*.

White is clean, clear, healthy, moral, rational, masterful . . . White, it seems, was everywhere, at least in the minds of Le Corbusier's contemporaries and followers. Theo van Doesburg, for example:

> WHITE is the spiritual colour of our times, the clearness which directs all our actions. It is neither grey white nor ivory white, but pure white.
> WHITE is the colour of modern times, the colour which

dissipates a whole era; our era is one of perfection, purity and certitude.

WHITE It includes everything.

We have superseded both the 'brown' of decadence and classicism and the 'blue' of divisionism, the cult of the blue sky, the gods with green beards and the spectrum.

WHITE pure white.[19]

In Le Corbusier's intoxicated rationalism, the rhetoric of order, purity and truth is inscribed in a pure, blinding white surface. So blinding, in fact, that the discourse of modern architecture has almost entirely failed to notice that most of his buildings are actually *coloured*. This marvellous paradox in the rhetoric of whiteness has been carefully picked apart by Mark Widgley, who has observed, for example, that Le Corbusier's manifesto building, the Pavillon de l'Esprit Nouveau, built in the same year as *The Decorative Arts of Today* was written, was actually painted in ten different colours: white, black, light grey, dark grey, yellow ochre, pale yellow ochre, burnt sienna, dark burnt sienna and light blue. Widgley has noted that Le Corbusier only ever made one white building. In spite of this, he has argued, there is 'a self-imposed blindness . . . shared by almost all of the dominant historiographies . . . Colour is detached from the master narrative' of architecture. Once again, it appears that we are not dealing with something as simple as white things and white surfaces, with white as an empirically verifiable fact or as a colour. Rather, we are in the realm of *whiteness*. White as myth, as an aesthetic fantasy, a fantasy so strong that it summons up negative hallucinations, so intense that it produces a blindness to colour, even when colour is literally in front of your face.

In *Purism*, a manifesto for painting co-written in 1920 with Amédée Ozenfant, Le Corbusier writes of painting as a kind of architecture: 'A painting is an association of purified, related, and architectured elements;' 'Painting is a question of architecture.'[20] In later writing, he often describes

architecture as a kind of painting, a process that follows the academic logic from 'composition', through 'contour', to 'light and shade'. If this is the case, if architecture is a kind of painting as much as painting is a kind of architecture, then Le Corbusier, like Blanc before him, was forced by his own logic to recognize the presence of colour in a work. This he did, and in a very similar way to Blanc. *Purism* is ultra-rationalist; the text is speckled with terms such as 'logic', 'order', 'control', 'constant', 'certainty', 'severe', 'system', 'fixed', 'universal', 'mathematical' and so on. But, as the authors acknowledge, 'when one says painting, inevitably he says colour.' And in the Purist universe, colour is a problem, a 'perilous agent'; it has the 'properties of shock' and a 'formidable fatality'; it often 'destroys or disorganises' an art which aims to address itself 'to the elevated faculties of the mind'.

Colour, then, must be controlled. It must be ordered and classified; a hierarchy must be established. And so it is. Le Corbusier and Ozenfant come up with three 'scales' for colour: the 'major scale', the 'dynamic scale' and the 'transitional scale'. The major scale is made up of 'ochre yellows, reds, earths, white, black, ultramarine blue and . . . certain of their derivatives'. This scale is 'strong' and 'stable'; it gives 'unity' and 'balance'; these colours are 'constructive' and are employed 'in all the great periods'. And they are also almost exactly the colours employed by Le Corbusier in his 1925 Pavilion. The dynamic scale is made up of 'disturbing elements': citron yellow, oranges, vermilions and other 'animated', 'agitated' colours; the transitional scale, 'the madders, emerald green, and all the lakes', are simply 'not of construction'. A painting 'cannot be made without colour', but the painter is advised to stick with the major scale; therein lies the tradition of great painting. The further one drifts down the scale of colour, the further one drifts from the 'architectural aesthetic' to the 'aesthetic of printed cloth' – that is, the further one drifts from art to mere decoration. This, in the end, was Cézanne's 'error', for he 'accepted without examination the attractive offer of the colour-vendor, in a period marked by a fad for colour-chemistry, a science with no possible effect on great

painting'. Such 'sensory jubilations of the paint tube' were best left 'to the clothes-dyers', because while painting could not be made without colour, 'in a true and durable plastic work, it is *form* which comes first and everything else should be subordinated to it.' The 'architectural' aesthetic of painting was concerned with the unified representation of volumes (whereas the clothes-dyers' aesthetic was limited to flat patterns); colours of the 'major scale' were strong and stable insofar as they served and emphasized this representation of volume. The same logic applies to the 'painterly' aesthetic of Le Corbusier's architecture: the function of coloured planes in a space is to render the volumes and spaces more balanced and coherent, more exact and, in the end, more white: 'To tell the truth, my house does not seem white unless I have disposed the active forces of colours and values in the appropriate places.' White must be whiter than white, and to achieve that, colour must be added.

It doesn't much matter whether this hierarchy of colours is coherent, any more than it matters whether Blanc's cosmology of colour makes any real sense. What matters is the show of force: the rhetorical subordination of colour to the rule of line and the higher concerns of the mind. No longer intoxicating, narcotic or orgasmic, colour is learned, ordered, subordinated and tamed. Broken.

Apocalypstick

Chromophobic or chromophilic, there is usually something apocalyptic in these stories of colour. Something oceanic, perhaps. Colour is dangerous. It is a drug, a loss of consciousness, a kind of blindness – at least for a moment. Colour requires, or results in, or perhaps just is, a loss of focus, of identity, of self. A loss of mind, a kind of delirium, a kind of madness perhaps. But not always, and not for everyone. At the other end of the spectrum, so to speak, there is colour of another and altogether less cataclysmic and dangerous kind: cosmetic colour.

If one group of stories typically involves a descent into an existing but hidden realm of colour, this other group of stories often involves the imposition of an artificial or illusory layer of colour upon a monochromatic world. That is to say, in one group colour lies beneath the surface; in the other group, it is laid over the surface. In one group, colour lies hidden within; in the other, colour is applied from without. And yet, despite all these differences and apparent oppositions, cosmetic colour stories often end up in, lead towards or threaten something very similar to their more dangerous counterparts: a Fall. And just as there are many ways to fall

into colour, so there are many ways of applying the make-up of colour; cosmetics can be laid on thick or thin, with subtlety or with a spade.

In *Moby Dick*, Melville refers to light, his colouring agent, as a 'mystical cosmetic'. Now that is a truly strange pairing: 'mystical' and 'cosmetic'. One term speaks of profound idealism, essential oneness, subliminity, invisible and indivisible bonding. The other term speaks of altogether more local, visible and vulgar concerns. If the cosmetic is essentially anything, it is essentially visible. Too visible, merely visible: changes that are *merely cosmetic* are not meant to hold our attention for long. The cosmetic is essentially visible, essentially superficial and thinner than the skin onto which it is applied. Cosmetics adorn, embellish, supplement. If colour is cosmetic, it is added to the surface of things, and probably at the last moment. It does not have a place *within* things; it is an afterthought; it can be rubbed off. Remember the coloured patches on the harlequin's clothes in *Heart of Darkness*. They were sewn on; Marlow could see the stitching.

Figuratively, colour has always meant the less-than-true and the not-quite-real. The Latin *colorem* is related to *celare*, to hide or conceal; in Middle English 'to colour' is to embellish or adorn, to disguise, to render specious or plausible, to misrepresent.

Colour, then, is arbitrary and unreal: mere make-up. But while it may be superficial, that is not quite the same as it being trivial, for cosmetic colour is also always less than honest. There is an ambiguity in make-up; cosmetics can often confuse, cast doubt, mask or manipulate; they can produce illusions or deceptions – and this makes them sound more than a little like drugs. Drugs that are applied to the body: drugs of the skin. If colour is a cosmetic, it is also – and again – coded as feminine. Colour is a supplement, but it is also, potentially, a seduction. Cosmetics make flesh more appealing, flesh that may be tired or old, or flesh that may be diseased, disfigured, decayed or even dead. In an atypical remark, Barthes writes in *Camera Lucida* that he always felt, irrespective of what was

actually the case, that colour was 'a coating applied *later on* to the original truth of the black-and-white photograph. For me, colour is an artifice, a cosmetic (like the kind used to paint corpses).'[1] Melville applied his cosmetic colour more subtly than Barthes. His was a necessary supplement; his light was a complex interweaving of faith and falsity, an indissoluble mixture of illumination and illusion. For Barthes, in this instance, colour was against truth; it was both a denial of death and a fiction of life. In any case, it was always after the event.

Kant: 'The colours which give brilliancy to a sketch are a part of the charm. They may no doubt, in their own way, enliven the object for sensation, but make it really worth looking at and beautiful they cannot.'[2] Ingres: 'Colour enhances a painting, but she is only a lady-in-waiting, because all she does is to make still more attractive the true perfections of art.'[3]

This association of colour, cosmetics and femininity goes back further than the eighteenth and nineteenth centuries, as far back as Antiquity. A chapter of Jacqueline Lichtenstein's *The Eloquence of Color* is titled 'On Platonic Cosmetics'. In it, she suggests that the Platonic opposition between philosophy and rhetoric was recast in Aristotelian aesthetics as an opposition between line and colour – *disegno* versus *colore*. What is remarkable about her account is the consistency it reveals between the Platonic image of rhetoric and a range of classical, modern and contemporary images of colour. For Plato, the medium for his image of rhetoric was the dangerous trivia of cosmetics: 'A fraudulent, baseborn, slavish knave; it tricks us with padding and makeup and polish and clothes, so that people carry around beauty not their own to the neglect of the beauty properly theirs through gymnastics.'[4] Vulgar, deceitful, lazy and dishonest, cosmetics perform their seductions while the nobility of true beauty is found in the rigours of physical and moral discipline. From this opposition sprang a whole tradition, as Lichtenstein notes sardonically, of 'moral puritanism and aesthetic austerity' in which '. . . only

what is insipid, odourless and colourless may be said to be true, beautiful, and good.' We are, she continues, the heirs of a 'metaphysical moral perspective that can see only a universe in black and white, stripped of adornments, washed of makeup, purged of all drugs that offend the mind and intoxicate the senses'.

Actually, it's worse than that. As these quotations attest, Western philosophy is used to dealing with ideas of depth and surface, essence and appearance, or basis and superstructure, and this just about always translates into a moral distinction between the profound and the superficial. So where does colour lie along this well-worn path? Well, if colour is make-up, then it is not really on this path at all, and perhaps this is a part of the colour problem. If surface veils depth, if appearance masks essence, then make-up masks a mask, veils a veil, disguises a disguise. It is not simply a deception; it is a double deception. It is a surface on a surface, and thus even farther from substance than 'true' appearance. How things appear is one thing; how things appear to appear is another. Colour is a double illusion, a double deception. It is not just that colour is at the wrong end of a moral opposition; it is, perhaps, just *beyond* the wrong end.

For Plato, the colour of rhetoric was false and artificial, immoral and unnatural. It was in full knowledge of the 'metaphysical moral perspective' that Baudelaire began his assault on Nature. 'In Praise of Makeup' is an often-overlooked passage in *The Painter of Modern Life*. Here, the poet praises 'artificiality' and 'adornment' as 'signs of the primitive nobility of the human soul', whereas 'nature teaches nothing or nearly nothing' and can in the end 'do nothing but counsel crime'.[5] It was in the context of this reversal of the traditional opposition that Baudelaire's celebration and defence of colour occurred:

> I referred just now to the remarks of certain *masons*. For me, the word describes that class of gross materialistic minds (their number is legion) that take an appreciative interest in objects

only by their contour or worse still on a three-dimensional basis: breadth, length and depth, just as savages or peasants do. I have often heard people of that sort draw up a hierarchy of qualities, which was totally unintelligible to me; they would maintain, for example, that the faculty that enables this man to create an exact contour or that man a contour of supernatural beauty is superior to the faculty that can assemble colours in an enchanting manner. According to these people colour has no power to dream, to think or speak. It would appear that when I contemplate the works of those men especially known as colourists, I am giving myself up to a pleasure that is not of a noble kind . . .

Here, colour is a sign of civilization, not of its Fall; it speaks of nobility rather than of the 'fraudulent' and 'baseborn'; an appreciation of colour indicates a rise above nature, not a fall into its lower strata. It is 'peasants and savages' who denigrate colour, not the aficionado of modernity, not the sophisticated *flâneur* who glides silently and invisibly through a world where *everything* has become surface.

And there's something else. If colour has 'the power to dream, to think or speak', then it is a very dangerous cosmetic, not a quiet and patient lady-in-waiting. (Serge Gainsbourg wrote the song – 'Apocalypstick' – and Jane Birkin sang it.) For Baudelaire, colour had perhaps the greatest power of all: the power to be autonomous. Barthes, writing about painting rather than photography, saw the same value in colour: 'If I were a painter, I should paint only colours: this field seems to me freed both of the Law (no Imitation, no Analogy) and Nature (for after all, do not the colours in Nature come from the painters?)'.[6] To be freed of the Law and Nature: what better description of autonomy could there be?

To be freed of the Law and Nature might also describe the quest of Des Esseintes, the hero of J.-K. Huysmans' novel *A Rebours*. Published in 1884 and translated into English as *Against Nature*, Des Esseintes'

assault on nature is simultaneously a celebration of artifice; as often as not, this is achieved through the meticulous orchestration of intense and 'artificial' colours:

> He had long been a connoisseur of colours both simple and subtle. In former years, when he had been in the habit of inviting women to his house, he had fitted out a boudoir with delicate carved furniture in pale Japanese camphor-wood under a sort of canopy of pink Indian satin, so that their flesh borrowed soft warm tints from the light which hidden lamps filtered through the awning. This room, where mirror echoed mirror, and every wall reflected an endless succession of pink boudoirs, had been the talk of all his mistresses, who loved steeping their nakedness in this warm bath of rosy light and breathing in the aromatic odours given off by the camphor-wood.[7]

One of the advantages of 'this tinted atmosphere' is that it brings 'a ruddy flush to complexions worn and discoloured by the habitual use of cosmetics . . .' In Des Esseintes' mind, an intense connection is already being made between colour, sex, orientalism, artifice, cosmetics and intoxication. And the story has hardly started.

Much of Huysmans's book describes the ways in which Des Esseintes tries, usually in vain, to achieve an all-enveloping atmosphere of colour. 'What he wanted was colours which would appear stronger and clearer in artificial light,' colours that would look 'crude or insipid in daylight'. At one point, he decides that his ornate Oriental furnishings need something more to enhance their shimmering effects:

> Looking one day at an Oriental carpet aglow with iridescent colours, and following with his eyes the silvery glints running the weft of the wool, which was a combination of yellow and plum, he had thought what a good idea it would be to place

on this carpet something that would move about and be dark enough to set off these gleaming tints.

This something turns out to be a large tortoise, which he then decides to have gilded and encrusted with precious stones. But the stones – these lower forms of nature which somehow never seem to be far from the discussion of colour – present Des Esseintes with a problem. For although colour and artifice represent for him a kind of aristocratic resistance to utilitarian bourgeois culture, the brilliant sparkle of precious stones had also been appropriated by the 'common herd':

> Choosing the stones gave him pause. The diamond . . . had become terribly vulgar now that every businessman wears one on his little finger; Oriental emeralds and rubies are not so degraded . . . but they are too reminiscent of the red and green eyes of certain Paris busses . . . as for topazes, whether pink or yellow, they are cheap stones, dear to the people of the small shopkeeper class . . . Similarly . . . the amethyst . . . has been debased by use on the red ears and on the tubulous fingers of butchers' wives . . . Alone among these stones, the sapphire has kept its fires inviolate, unsullied by contact with commercial and financial stupidity.

Eventually, Des Esseintes settles for more 'startling and unusual' gems and a few artificial stones. The tortoise is elaborately decorated; Des Esseintes admires his creation as it lies 'huddled in a corner of the dining room, glittering brightly in the half-light'; he drinks china tea from Oriental porcelain. The next day the animal is dead.

The story of the tortoise is perhaps a moral tale about the dangers of overdoing the make-up. While cosmetics can both enhance beauty and conceal ugliness, they can also suffocate life. They really are against nature; they can be used to decorate a corpse, but they can also make a corpse

of what they decorate. Huysmans' tortoise is the through-the-looking-glass version of Baudelaire's brightly coloured bird: as one hovers weightlessly and sings perfectly, the other sits immobile and silent, a slow, heavy animal made slower and heavier by its added encrustations. One is the fleeting triumph of life over death; the other is the permanent victory of death over life.

What happened to the tortoise hints at what might happen to Des Esseintes himself – this is, after all, also a story of a Fall. But not before he has figured out the problem of flowers. For flowers, like precious stones, are both brilliantly coloured and often utterly commonplace. And flowers are also *of* nature rather than *against* it. Des Esseintes begins his careful selection by classifying flowers in terms of social class. He identifies the 'poor, vulgar slum-flowers', a middle class of 'pretentious, conventional, stupid flowers' and, lastly, 'flowers of charm and tremendous delicacy . . . princesses of the vegetable kingdom, living aloof and apart, having nothing whatever in common with the popular plants or the bourgeois blooms'. Naturally, Des Esseintes admires only the 'rare and aristocratic plants from distant lands', and these mainly for their very unnaturalness, as they are kept alive only 'with cunning attention in artificial tropics'. This 'inborn taste for the artificial' in turn leads him – in an entirely postmodern way – to begin 'to neglect the real flower for its copy', which in turn leads him to cultivate an interest in flowers that are literally artificial, those 'faithfully and almost miraculously executed in indiarubber and wire, calico and taffeta, paper and velvet'. And yet he is still not quite satisfied – which is, perhaps, the entire point and dynamic of the book. Des Esseintes is never satisfied with his orchestrations of artificiality, perhaps because even the most extreme artifice, once familiar, becomes a kind of nature to him.

So he turns his attention to another kind of flora: 'tired of artificial flowers aping real ones, he wanted some natural flowers that would look like fakes.' On taking delivery of these naturally artificial blooms,

Des Esseintes falls into a kind of delirium or conscious dream-state, which, in some respects at least, is not unlike Le Corbusier's Oriental delirium. Glancing from flower to flower and inspired mainly by the exotic plants' intense colours, he begins to blur the distinction between flower parts and animal parts, between different types of flesh, between the vegetable and the mineral, between the healthy and the diseased. One plant 'looked as if it had been fashioned out of the pleura of an ox or the diaphanous bladder of a pig'; another 'seemed to be simulating zinc, parodying bits of punched metal coloured emperor green and spattered with drops of oil paint, streaks of red lead and white'; another 'flaunted leaves the colour of raw meat, with dark red ribs and purplish fibrils, puffy leaves that seemed to be sweating blood and wine'. Most of the plants summoned images of disease, appeared 'ravaged by syphilis or leprosy'. Some had 'the bright pink colour of a scar that is healing or the brown tint of a scab that is forming'; another 'thrust its ghastly pink blossoms out of cotton-wool compresses, like the stumps of amputated limbs'; yet another was 'opening its sword-shaped petals to reveal gaping flesh-wounds'. Eventually, Des Esseintes becomes exhausted by the 'crude and dazzling colours' of his 'depraved' and 'unhealthy' hothouse collection. Gradually, his conscious colour-delirium leads him to fall into a restless sleep and then into a colour-nightmare where the flowers transform into a woman and the woman in turn becomes flower-like: 'glowing colours lit up her eyes; her lips took on the fierce red of Anthuriums; the nipples of her bosom shone as brightly as two red peppers.' To his horror the woman embraces him fiercely and reveals 'the savage Nidularium blossoming between her uplifted thighs, with its swordblades gaping open to expose the bloody depths'. He wakes up. The nightmare confirms what he already knows from the flowers: 'It all comes down to syphilis in the end.' Within days, most of the flowers are dying or dead.

For Huysmans, intense colour, even intense natural colour, broke free from its moorings in nature. It flooded the eyes and disoriented

the mind, as it did for Le Corbusier, Cézanne, Barthes, Huxley and Dorothy. Des Esseintes is caught in the spell of colour, or, more directly, he is just caught in colour. Between them, colour and artifice produce a kind of terror. Through the medium of colour, flowers become women and sex becomes death. And yet it is also clear to Des Esseintes that without colour there is no life. If colour is a kind of corruption which heralds disease and death, corruption is also a kind of colour which gives life. This is shown most clearly in a chapter in which he discourses on the development of the Latin classics. He rails against the 'pure' Latin of the 'Golden Age', an idiom 'without suppleness of syntax, without colour, without even light and shade; pressed flat along all its seams and stripped of the crude but often picturesque expressions of earlier epochs', an idiom that could only 'enunciate the pompous platitudes and vague commonplaces'. He sneers at its 'dreary colour' or denounces it as 'turgid and colourless'; the image is always of something ossified, decrepit, heavy, inflexible, dull and deathly, full of 'redundant metaphors and the rambling digressions of an old Chick-Pea', 'well-fed and well-covered, but weak boned and running to fat' – something quite incapable of invention and renewal. The only work he praises in the Latin canon is the *Satyricon* by Petronius, a narrative of the 'day-to-day existence of the common people', told with

> extraordinary vigour and precise colouring, in a style that makes free with every dialect, that borrows expressions from all the languages imported into Rome, that extends the frontiers and breaks the fetters of the so-called Golden Age, that makes every man talk in his own idiom – uneducated freedmen in vulgar Latin, the language of the streets; foreigners in their barbaric lingo, shot with words and phrases from African, Syrian, and Greek . . .

Corruption, for Des Esseintes, breathes life; impurity renews and refreshes; contamination extends, animates and colours. And it comes

from the East. And it is vulgar. Purity, on the other hand, is dull and turgid. Its colourlessness is pathological: anaemic, or worse.

Andy Warhol was the great artist of modern cosmetics. His innumerable *Marilyn*s are homages to make-up, as are his *Liz*'s, his *Self Portrait*s, his *Disaster*s and his *Flower*s. It is as if each day colour was reconfigured and reapplied. Warhol's colour is supremely artificial. Barthes called it 'chemical', in that it 'aggressively refers to the artifice of chemistry, in its opposition to Nature'.[8] And in Warhol's work there is always a distinction between the form and its colouring, a misregistration of line and colour. Warhol's signature failure to keep colour in line – his failure to contain and corral his vivid pinks, oranges, reds, yellows and turquoises within the discipline of a contour – is one of his great successes. In his work in general, his *disegno* and *colore* are in a constant state of mutual agitation. On the one hand, his colour does to the canvas exactly what, for Barthes, colour did to photographs. It is 'an artifice, a cosmetic'; it could be rubbed off or washed away. And sometimes it was washed away by Warhol himself. There are many linear *Marilyn*s, many *Marilyn*s that are black lines and tones screen-printed onto grey canvas. But in Warhol's universe, these monochrome *Marilyn*s are no more real than his hyperchromatic versions. The artifice is in the drawing as much as it is in the colour. The reality of Marilyn is in the artifice. These works can appear as perverse rehearsals of the Academic habit and hierarchy of composition-contour-chiaroscuro-colour. Except that, instead of forming an indissoluble unity, each element remains intact, discrete, autonomous. That *is* the unity of a Warhol. Colour is never reduced to mere 'tinted chiaroscuro'; it is never subordinated to volume and space. Warhol's colour chemistry has the opposite effect: it destroys volume, space and modelling; the cosmetic is everywhere and everywhere evenly applied: to lips, face, figure, ground. Warhol's early *Do It Yourself* painting-by-number paintings play the game of drawing and colouring-in, but the colouring-in is rarely if ever finished. If it was, it would destroy the picture. And if in these works the official

hierarchy of line and colour is mechanically preserved or mimicked, in many of the later screen-printed works colour precedes line: an image is printed over a brightly coloured monochrome canvas. Here, line is a cosmetic – mascara – applied to a already-coloured surface. In these works, *il n'y a pas de hors cosmétique*.

In at least one sense, all painting is cosmetic. All painting involves the smearing of coloured paste over a flat, bland surface, and it is done in order to trick and deceive a viewer, a viewer who wants to be tricked and deceived into seeing something that is not there. And behind the make-up which is painting, there is nothing. There is no substance beneath the surface, no depth behind the appearance. The same is true, of course, for film, which to our eyes is often a more mystical cosmetic than painting. Behind the dancing coloured light, there is just another flat screen, a monochrome-in-the-world of which we are reminded at the beginning and end of every movie.

In one sense, all painting is cosmetic, but in another sense the use of flat screen-printed and industrial colours will always appear cosmetic – applied, stuck on, removable – in a way that the modulated colours and tones of oil paint do not. We will return to this. In Warhol's work, cosmetics also lead us elsewhere: to dressing up, to cross-dressing, to drag. They are about sexual indeterminacy, about playing with the order of nature and going Against Nature in a very specific way. There is also much sexual indeterminacy in *A Rebours*: at the beginning, we are told that Des Esseintes was the scion of a family which over generations saw 'men becoming progressively less manly'; it is not long before, during a fantasy about a female prostitute gradually changing sex, he reaches the point of 'imagining that he, for his part was turning female'. Warhol's work is a bit different, even if his silver-painted, daylight-excluding Factory sounds like a rough New York version of one of Des Esseintes' artificial interiors. But as Mandy Merck has noted, 'the transvestite has often been named as the central figure of Warhol's work,' and there is perhaps no-one for whom

make-up is more important than the drag queen.[9] The figure of the drag-queen is marked, like the figure of rhetoric was for Plato, as a simulacrum, a copy without an original, something entirely artificial and uncertain. In this sense, it is much like cosmetic colour: its aim is to confuse and seduce, to fake and cover up. And there is another respect in which Merck's argument is interesting here: it centres on the image of Warhol's *Diamond Dust Shoes*. These are pictures whose artificial sparkle will, of course, always carry a memory of Dorothy's Ruby Slippers; they are pictures sprinkled in the language of the lower forms of nature, pictures which, although darkly colourful, are also coated in the quintessential *symbol* of colour as ornament, excess and otherness.

Colour is often close to the body and never far from sexuality, be it heterosexual or homosexual. When sex comes into the story, colour tends to come with it, and when colour occurs, sex is often not too far away. In *Color Codes*, Charles A. Riley notes a tendency to associate colour with male homosexuality. He gives the example of a recent biography of Benjamin Britten which 'rather loosely plays with the notion that the composer's more "chromatic" passages and dissonances are linked to the "unnatural" or homosexual side of his behaviour, while the major or "white" passages correspond to society's normal expectations.'[10] In *Chroma*, Derek Jarman's short, moving, epigrammatic book on colour written while he was suffering from Aids and going blind, a rather different account is offered:

In the 1430s a fourteen-year-old-boy could be burned at the stake for an act of sodomy – this would not happen in Florence again [after the Renaissance]. Platonism confirmed that it was right and proper to love someone of your own sex – a more practical way of viewing sexuality than the church's blueprint of DON'Ts. The modern world received the message with open arms and Botticelli, Pontormo, Rosso, Michaelangelo and

Leonardo stepped from the shadows. I know this is a long way from light and colour ... but is it? For Leonardo took the first step into light, and Newton, a notorious bachelor, followed him with *Optics*. In this century Ludwig Wittgenstein wrote his *Remarks on Colour*. Colour seems to have a Queer bent.[11]

'Normality' is clothed in black and white; colour is added and, for better or worse, it all begins to fall apart. Colour may or may not have homoerotic content, but its association with irregularity or excess of one kind or another is quite common and, in some cases, quite explicit. In *Flatland*, Edwin Abbott's 1884 science-fictional, two-dimensional world inhabited entirely by lines and geometric shapes, everything is order, hierarchy and regularity. This is a determinist universe in which a fixed social and biological order prevails. On the lowest rung of the evolutionary ladder are straight lines (women); we ascend slowly through the male scale of isosceles triangles (workers and soldiers), equilateral triangles (tradesmen) and squares and pentagons (professionals), and arrive at a polygonal nobility and circular priestly order. The world is flat, linear, monochrome and more or less stable. Until, that is, colour is discovered. At first, Chromatistes (as he becomes known), a pentagon, decorates his surroundings, his house, his servants and himself. Then the fashion catches on:

> Before a week was over, every Square and Triangle in the district had copied the example of Chromatistes, and only a few of the more conservative pentagons still held out. A month or two found even the Dodecagons infected with the innovation. A year had not elapsed before the habit spread to all but the very highest of the Nobility.[12]

And, interestingly, to women, who with the priests 'remained pure from the pollution of paint'. This time came to be known as the Colour Revolt; it brought out fledgling democratic and anarchist tendencies in the

lower classes; lowly triangles claimed parity with more complex polygons on the basis that everyone had equal capacity for Colour Recognition. As a 'second Nature', colour, it was argued, had 'destroyed the need of aristocratic distinctions', and thus 'the Law should follow in the same path and henceforth all individuals and all classes should be recognised as absolutely equal and entitled to equal rights.' In the name of this radical democracy, even priests and women 'should do homage to colour by submitting to be painted'. Declaring a Universal Colour Bill, the revolutionaries demanded specifically that women and priests be painted the same two colours (red and green) – the unstated aim being to gain the support of the former group and undermine the power of the latter. Three years of agitation and anarchy followed; the introduction of colour threatened to topple the entire social order: 'With the universal adoption of Colour, all distinctions would cease; Regularity would be confused with Irregularity; development would give way to retrogression.' Colour, its opponents argued, would cause 'fraud, deception, hypocrisy' to corrupt every household. A violent battle ensued; many lives were lost. Eventually, the status quo prevailed and the Laws and Constitution of Flatland were upheld. 'Chromatic Sedition' was suppressed. Colour was abolished.

Abbott was a schoolteacher who originally devised his tale to instruct his pupils in the basics of geometry and the idea of dimensions – it goes on to introduce a three-dimensional world, 'Spaceland', and to hypothesize others. And yet the narrative soon exceeds its initial purpose and becomes as much social satire as 'spiritual parable'. Abbott's two-dimensional universe bears more than a passing resemblance to Blanc's monochromatic world in which a fall into colour was an ever-present danger, except of course that this time the world is expressed in a social rather than a biblical way. Colour threatens – or promises – to undo all the hard-won achievements of culture. It threatens – or promises – chaos and irregularity. Colour threatens disorder – but also promises liberty.

According to 'Wild' Bob Burgos, drummer of The Savages, 'he wasn't

a nutcase. He was a genuinely nice person who loved his rock 'n' roll and wanted colour in politics.' According to Frank Dobson, Health Secretary of the Blair government, he was 'a very amiable guy who added a bit of colour to what were sometimes rather dull proceedings.'[13] William Hague, leader of the Tory Party, thought of him as 'one of the most remarkable and colourful figures in modern British politics'. And for Charles Kennedy, leader of the Liberal Democrats, he would be remembered as, among other things, 'a colourful political personality'.[14] Burgos and Dobson were reflecting on the loss to British politics caused by the death in June 1999 of Screaming Lord Sutch, one time pop star and long-time leader of the Monster Raving Loony Party. Hague and Kennedy were paying tribute to Alan Clark, the Conservative politician and son of Lord Kenneth Clark, who died three months later. What the two had in common, it seems, was colour. But how was 'colour' being used here? What purpose did it serve to distinguish someone's personality in this way and, in doing so, to admit to the colourlessness of the world these characters inhabited? Alan Clark was a vegetarian, Thatcherite, animal-loving adulterer who thought it was a good idea to sell arms to just about anyone who had the money. He named his dogs after Hitler's mistresses and referred to Africa as Bongo-Bongo Land. Screaming Lord Sutch ran a one-man Party; he wore silly hats and badges and thought the EU butter-mountain might be used as a ski-slope. In 36 years, he lost his deposit in every one of the 40 elections in which he stood as a candidate.

At best, these men were described as free-thinkers and mavericks; at worst as fools and wasters. At best, they were independently minded participants in a culture that rewards conformity – dutiful, cynical, hypocritical, whatever – above just about everything else. Colour here connotes the slightly wild. Inconsistent in their thinking, perhaps, and therefore unpredictable and confusing, but in another sense consistently true to themselves. As in Flatland, these two individuals represented the disobedient, the eccentric, the irregular and the subversive. But, unlike

Chromatistes, they were not quite dangerous. Well, not quite safe either, but always more of a danger to themselves and therefore a danger contained. Roguish. Entertaining. Dissenting. Irritating. Attractive. But, when push came to shove, dispensable, supplementary and, finally, cosmetic. Clowns. Court jesters. To be called colourful is to be flattered and insulted at the same time. To be colourful is to be distinctive and, equally, to be dismissed. The main consolation is the colourlessness of the culture from which the colourful are exempted, the greyness of those for whom colour is a mark of exception. In the colourless Flatland of Parliament, colour only ever seems to engulf the colourful. They burn brightly, and then they die. The colourful illuminate their surroundings, but they consume themselves in the process. That is perhaps why people rush to write such fond and smiling obituaries. Such testaments are brimming with jolly anecdotes and amusing memories, and then garnished with appropriate notes of sadness. But their unspoken moral is surely that the embryo of their death was also in their colour. Such peoples' obituaries are smiling with the knowledge that the colourful do not survive. (We knew they wouldn't.) They pay the price of their colour. (We knew they would.) And in knowing that, we know that for all our own greyness we will at least have the last word.

In *Pleasantville*, as in Flatland and Oz and in many other stories of a world made colourful, colour makes an unexpected appearance in an otherwise grey universe. Two adolescents are miraculously displaced from the multicoloured and troubled 1990s by being sucked through a television into a black-and-white 'Hi-Honey-I'm-home' late-1950s family sitcom. This world – the Pleasantville of the title – is also like Flatland, Parliament and Kansas because it represents order, regularity and stability. Nothing changes. Ever. Nothing is out of place, and everyone and everything circulates in completely frictionless and apparently blissful orbits of daily repetition. There are no toilets in Pleasantville. Apart from eating, which is done in huge quantities without any obvious effects of any kind

at all, there are no bodily functions of any description to complicate the inhabitants' smiling and trouble-free lives. Pleasantville is not exactly what Bakhtin had in mind when he characterized the hermetically sealed and lifeless classicism of Stalinist art, but it is in its way a parallel McCarthyite universe. The arrival of the knowing and cynical – and surprised – teenagers from another age heralds the arrival, little by little, of colour. And with colour comes disruption, discontinuity, confusion, passion and, above all, sex. Things begin to change, and Pleasantville begins to fall apart. (Roland Barthes, on sex and colour: 'Current opinion holds sexuality to be aggressive. Hence the notion of a happy, gentle, sensual, jubilant sexuality is never to be found in any text. Where are we to read it, then? In painting, or better still, in colour.'[15])

The arrival of colour in Pleasantville has many of the same effects it had in Flatland. People who knew their place in the order of things start to desire more and differently and, well, just to desire. When the short-order chef in the burger joint finds colour in books on art and paints a cubist Santa mural in the window, this causes a riot among the town's chromoclasts, who destroy it along with books whose previously empty pages become gradually filled with stories, pictures and colours. When a boy who has been kissed – and more – by the '90s girl explains something about his experience to the school basketball team, all their shots, which until that time had been universally and unerringly on target, fly all over the place and hit anything but the hoop. When word gets round and teenagers begin to behave like teenagers – having sex, listening to music and dancing – they become coloured. A girl gives a boy an apple in a garden; it begins to rain; a rainbow appears. The world gradually turns to colour, as feeling and passion trickle and then flood into the town-people's lives. But not before the town fathers issue decrees and pledge allegiance to the 'non-changist view of history, emphasising continuity over alteration', and the Chamber of Commerce meets to ratify a code of conduct which bans colours, only licencing the use of black, white

and grey. But to no avail: there is in the end no resistance to colour. It becomes permanent. For that reason, Pleasantville is not another Flatland or Kansas.

Pleasantville is for the most part a light and very funny satire on the sentimentality of television and on American nostalgia for a mythical world untroubled by dissent from within and disruption from without. If such a world had ever existed, it would have been a kind of purgatory, the film tells us. Colour is uncertainty, doubt and change, but without it there is only the Law and Home. But there are also moments and images in the story that far exceed the film's more obvious subject matter. Many of these coincide with a technically brilliant use of reflections, in particular reflected colour: from the moments at the beginning and at the end of the movie when the teenagers see their own reflections in the switched-off television screen, to the brief scene when a group of obnoxious and disapproving old men stare off-screen at a young woman whose beautiful reflection is glimpsed momentarily in the shop window behind them – a momentary and indirect flare of colour in an otherwise monochrome world. But by far the most moving scenes in the film concern the teenagers' 1950s mother and her growing awareness of her body and her repressed sexuality. After the facts of life have been explained to her (by her daughter), she runs a bath, lies in it and begins to masturbate. As her arousal grows, one by one the bathroom ornaments and decorations dissolve into colour, and as she climaxes, a grey tree in the monochrome garden outside the bathroom spontaneously bursts into Technicolor flames. She comes in colours, but the arriving firemen and onlookers, entirely mystified by the flaming tree (the firemen have previously only ever rescued cats from trees), only catch the glow of the fire on their stunned grey faces.

There is another very beautiful scene in *Pleasantville* that is also a beautifully original reversal of the conventional image of colour and make-up. It is the centrepiece of the movie, and again its focus is the mother figure. Having reached her state of coloured awareness, having

become other to Pleasantville while remaining in Pleasantville, she is faced with the prospect of confronting her husband, the Father, the Law. Alarmed and uncertain, this time she seeks the advice of her '90s son. Together, they hatch a plan, and, as the camera moves in on her face, he slowly and gently begins to apply a layer of grey make-up to her pink cheeks and red lips. Colour, again, is shown as permanent and irresistible; it cannot be rubbed out, only hidden beneath a monochrome mask, and only for a while . . .

We have come at colour from many different directions; we have seen it seep into the world and flood over it; we have seen it rubbed out and covered over; we have seen it kill and be killed and give life and deny death. But whichever way we have come at it, it is difficult to avoid the conclusion that colour is a very peculiar other, and that it is almost never *less* than other. We usually expect or demand of otherness that it be marked in some way, the better to distinguish it from our fine and cherished selves. As often as not, that has come to mean a physical mark of some kind, in order that a spatial separation can be made, at least in the imagination. The other is over there: geographically or physiognomically distinct. But the other that is colour is everywhere: around and in and of us, a part of everything we see every day in our every waking moment. Even night fails to shroud or abolish colour entirely, as for many of us colour seeps into our dreams. Perhaps that is the point: the other that is colour can *only* be imagined away. And this may be one reason for all the attention given to it in certain types of philosophy or art, in certain theories of art or environments, or in certain kinds of stories. Because it is only in these realms that colour can be fully and finally eliminated: wished away by pure thought or washed away by pure form. In literature and the movies, we can picture the world without colour; the rest of the time, in our daily lives and nightly dreams, we are stuck with it. We are not just surrounded by colour; we are colour ourselves.

There are many stories of the world made colour, or colourless, and

their lessons are often contradictory and confusing. Colour is both a fall into nature, which may in turn be a fall from grace or a fall into grace, and against nature, which may result in a corruption of nature or freedom from its corrupting forces. Colour is a lapse into decadence and a recovery of innocence, a false addition to a surface and the truth beneath that surface. Colour is disorder and liberty; it is a drug, but a drug that can intoxicate, poison or cure. Colour is all of these things, and more besides, but very rarely is colour just *neutral*. In this sense, chromophobia and chromophilia are both utterly opposed and rather alike. In particular, they are often remarkably similar in shape. On those occasions when colour is given a positive value, what is most striking is how its chromophobic image – as feminine, oriental, cosmetic, infantile, vulgar, narcotic and so on – is, for the most part, not blocked, stopped and turned around. Rather the opposite: in chromophilic accounts, this process is usually both continued and *accelerated*. Colour remains other; in fact, it often becomes more other than before. More dangerous, more disruptive, more excessive. And perhaps this is the point. Chromophobia might not really have its opposite in chromophilia; chromophobia might be seen as simply chromophilia's weak form. That is to say, chromophobia recognizes the otherness of colour but seeks to play it down, while chromophilia recognizes the otherness of colour and plays it up. Chromophobia is perhaps only chromophilia without the colour.

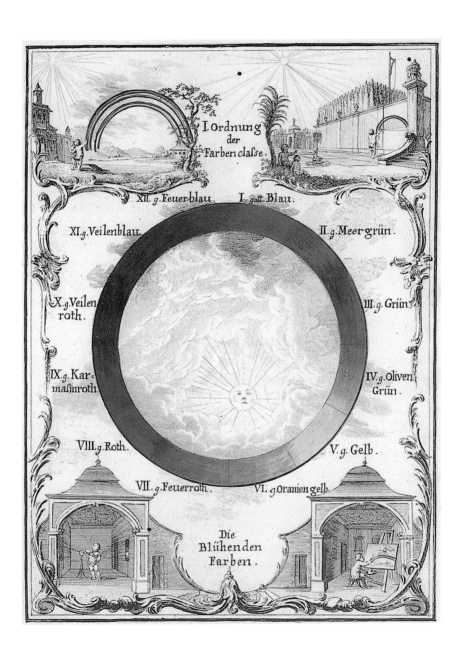

I. Ordnung
der
Farben classe.

XII. g. Feuerblau. I. gatt. Blau.

XI. g. Veilenblau. II. g. Meergrün.

X. g. Veilen- III. g. Grün.
roth.

IX. g. Kar- IV. g. Oliven
masinroth. Grün.

VIII. g. Roth. V. g. Gelb.

VII. g. Feuerroth. VI. g. Oranien gelb.

Die
Blühenden
Farben.

CHAPTER FOUR

Hanunoo

Why is it that so many colour stories, chromophobic and chromophilic alike, get caught in the spell of gems and precious stones? One answer would be that, for some, these natural fragments are extremely convenient. Specifically, they come from the 'East', or thereabouts. And they come from the 'earth'. Le Corbusier: '. . . one discovers and dislodges from beneath the piles of coarse earth the most sumptuous nuggets of the East . . .'[1] That is to say, these nuggets are *found* rather than made or crafted; they do not speak of skill or the human spirit so much as of good fortune – or perhaps greed, power and lust. Their brilliance does not connote a brilliant culture. On the contrary, possession of such stones (outside the noble and civilized centres of Europe, of course) is usually taken as a symptom of despotism and corruption. They may occur naturally, but they connote artifice and decadence. Here, for example, is Bernard Berenson, aesthete, classicist and chromophobe's chromophobe: 'The princes of Ormuz and of Ind who pass their fingers through sackfulls of precious stones, not only for the pride of power which great possessions give, but also for the touch, and perhaps chiefly for the gaiety and sparkle

of colour, will scarcely be credited with enjoying them as works of art.'[2] Clearly, there is much more to these stones than that. For many, their preciousness is not really the issue – after all, it didn't much matter to Des Esseintes whether his tortoise was coated in real or fake gems. Rather, as even Berenson noted, their chief value lies in their sparkle and luminosity. Here, colour is active; it is alive. Colour projects; it is not a passive coating of an inert object; light appears to shine from within; colour seems to have its own power source. Perhaps this is why gems often stand for colour-in-general. They represent the point at which colour becomes independent and assertive – or disruptive and excessive. For the tripping Aldous Huxley, colours became so intense that 'they seemed to be on the point of leaving the shelves to thrust themselves more insistently' on his attention.[3] For Le Corbusier, colour was explosive. For Barthes, colour could be 'like a pinprick in the corner of the eye'; it had the power to 'lacerate'.[4] For Baudelaire, colour had the capacity to think, speak and dream. In Des Esseintes' dream, the colour-flower-woman came towards him and threatened to engulf him. In each case, colour moved forward; it advanced; it was a disturbance, a danger, a threat. It could explode in your face or lacerate your eye. More than that: it was as if *colour was looking at you*.

In *Heaven and Hell*, his follow-up to *The Doors of Perception*, Huxley takes up this question of gems and their place in the literature of drugs and visions. He quotes an account of a peyote-induced hallucination in which the author saw 'fragments of stained glass' and 'huge precious stones', both of which 'seemed to possess an interior light'.[5] He goes on to list examples from Hindu, Buddhist and Judeo-Christian descriptions of paradise which are saturated with images of 'rivers . . . full of leaves the colour of sapphire and lapis lazuli', of countries 'covered by jewels and precious stones', and of lands adorned with 'stones of fire'. He quotes Ezekiel's vision: 'Thou hast been in Eden, the garden of God. Every precious stone was thy covering, the sardius, the topaz and the diamond,

the onyx and the jasper, the sapphire, the emerald and the carbuncle, and gold . . .' He concludes that 'Heaven is always a place of gems.'

For Huxley, it was not in itself the rarity of these stones that explained their place in the literature of paradise; it was, again, their colour. For this colour – intense, heightened, pure, unqualified – offered a glimpse of the 'Other World', a world beyond Nature and the Law, a world undimmed by language, concepts, meanings and uses. In a way, Huxley's other world may be as much an Oz as it is an Eden – at least there is very little he says about this realm that doesn't sound a bit like Dorothy's 'somewhere'-that-is-no-longer-Kansas. In Huxley's writing, mescaline or LSD takes you to the 'antipodes of the mind', a largely unexplored continent populated by 'exceedingly improbable' metaphorical mammals and marsupials – about as improbable as the inhabitants of Dorothy's vision. On the near side of the rainbow, in the land of the laws and orders of consciousness, there are also similarities between Huxley's and Dorothy's pictures. Dorothy's Kansas, as we know, is grey; Huxley's Kansas is language, as language greys the world around us. 'Colour turns out to be a kind of touchstone of reality. That which is given is coloured', he says, but the intellect, the conceptual structures and the symbol systems we impose on the world are in themselves abstract and colourless. And they in turn drain our perceptions of the colour that is around us. Furthermore, while the given is given to us in colour, this colour is weak and insipid compared with the brilliant and 'self-luminous' colours of the mind's antipodes:

> The non-symbolic inhabitants of the mind's antipodes exist in their own right, and like the given facts of the external world are coloured. Indeed, they are far more intensely coloured than external data. This may be explained, at least in part, by the fact that our perceptions of the external world are habitually clouded by the verbal notions in terms of which we do our thinking.

This is the key: intensity of colour is a measure for Huxley of our distance from language, just as for Dorothy it is a measure of her distance from Kansas.

Huxley's cosmology of colour is beautifully concise and clearly phrased, as was Charles Blanc's, and it is also worth quoting at greater length:

> Everything seen by those who visit the mind's antipodes is brilliantly illuminated and seems to shine from within. All colours are intensified to a pitch far beyond anything seen in the normal state, and at the same time the mind's capacity for recognising fine distinctions of tone and hue is notably heightened ... At the antipodes of the mind, we are more or less completely free of language, outside the system of conceptual thought. Consequently our perception of visionary objects possesses all the freshness, all the naked intensity, of experiences which have never been verbalised, never assimilated to lifeless abstractions. Their colour (that hallmark of givenness) shines forth with a brilliance which seems to us praeternatural, because it is in fact entirely natural – entirely natural in the sense of being entirely unsophisticated by language or the scientific, philosophical and utilitarian notions, by means of which we ordinarily re-create the given world in our own drearily human image.

In many respects, Huxley's vision is rather like Blanc's; it's just that it has been turned through 180 degrees. For both, there is language or the Idea at one pole; at the other pole, there are colours and precious stones. For Blanc, the job is to keep the poles apart, to avoid the Fall; for Huxley, it is to dive from one pole to the other, using whatever means necessary to get there. For both men, gems and shiny things are significant because they represent that which exists beyond the reach of language. In fact, Blanc does describe gems as a kind of language, but it is a paradoxical,

metaphorical and mute one, the language of the formless, a language entirely alien to human consciousness. For Huxley, precious stones are precious because they 'may remind our unconscious of what it enjoys at the mind's antipodes'. For both, in different ways, these shiny objects are unspeakable.

There is a parallel of sorts between Huxley's and Blanc's polarization of colour and language and Yves Klein's chromophile story of the 'war between line and colour', which exists as a storyboard he made in 1954 for an animated film. The main difference is that Klein imagined using the coloured light of the cinema rather than coloured stones to make his point (but isn't the mesmerizing illuminated screen of the cinema something like a modern equivalent of the sparkling gems of older times?). Klein's account is a very sketchy historical elaboration of the principal that underpinned his entire output as an artist, namely that 'colour is enslaved by line that becomes writing.'[6] That's a good phrase. Articulating more than a simple inversion of the standard *disegno*-versus-*colore* opposition, Klein also inverted the assumption, implicit in many academic accounts, that language precedes drawing, that the idea precedes the mark. Like Huxley and Blanc, Klein understood colour as a reminder of a remote and original state of being. As for Huxley, for Klein this was also a kind of unspoilt earthly paradise. But unlike Huxley and Blanc, who began their accounts in their presents and worked back to the moment of colour, Klein began with a screen of pure, uninterrupted colour – first white, then yellow, then red, then a deep ultramarine blue – and proceeded to disrupt it, scene by scene, with linear images of one kind or another – prehistoric hand prints, cave drawings, animals, hunters with bows and arrows, abstract engravings, hieroglyphics and so forth. His handwritten notes supply the narrative:

Taking advantage of a need tested by the first man to project his mark outside himself, line succeeded in introducing itself into

the heretofore inviolate realm of colour. Cain and Abel murder: dream-reality. Rapidly mastered, pure colour – the universal coloured soul in which the human soul bathed when in the state of the 'Earthly Paradise' – is imprisoned, compartmentalised, sheared, and reduced to a slave . . . In the joy and delirium of its victory by trickery, line subjugates man and imprints him with its abstract rhythm that is at once intellectual, material, and spiritual . . . Nevertheless, throughout the centuries, colour – tainted, humiliated, and conquered – prepares a revenge, an uprising that will be stronger than anything . . . Thus the history of the very long war between line and colour begins with the history of the human world. Heroic colour makes signs to man every time he feels the need to paint. It calls to him from deep within and from beyond his own soul . . . It winks to him but is enclosed by drawing inside of forms. Millions of years will pass before man understands these signs and puts himself suddenly and feverishly to work in order to free both colour and himself . . . Paradise is lost. The entanglement of lines becomes like the bars of a veritable prison . . . Man . . . is exiled far from his coloured soul.

Klein's account, like Blanc's, is written in a biblical register, only with references to the second generation of the Old Testament rather than the first. Klein also directly echoes Huxley's image of a paradise of pure, inviolate colour and his image of consciousness as a dimming of that colour. Enclosed by the abstraction of line which becomes writing, colour can only wink its presence. Colour might not have been abolished, but it only exists for us in a conquered and subjugated state. Nevertheless and in spite of this, colour retains its subversive potential; incomprehensible and mute, it offers a glimpse (a wink) of freedom. It is the exact opposite of the chromophobic anxiety of the contemporary architect we

met in chapter 1. For Klein, as for Cézanne and Huxley, our main problem is that we have fallen out of colour and into line, writing and language.

To attend to colour, then, is, in part, to attend to the limits of language. It is to try to imagine, often through the medium of language, what a world without language might be like.

Many commentators have taken the image of childhood as a model, if not for a language-free universe then at least for a world in which language has not yet fully established its grip on experience; this world is also, more often than not, saturated in colour. Baudelaire again: 'Nothing is more like what we call inspiration than the joy the child feels in drinking in shape and colour.'[7] And again: 'A friend of mine was telling me one day how, as a small boy, he used to be present when his father was dressing, and how he had always been filled with astonishment, mixed with delight, as he looked at the arm muscle, the colour tones of the skin tinged with rose and yellow, and the bluish network of the veins.' Or the critic Dave Hickey recalling the Saturday-morning Kiddie Cartoon Carnivals of his youth: 'What we wanted to *see* . . . was that wall of vibrant moving colour, so we could experience the momentary redemption of its ahistorical, extra-linguistic, sensual embrace – that instantaneous, ravishing intimation of paradise that confirmed our lives in the moment.'[8] (Here again, perhaps, is a hint that the colours of the movies, be they cartoons or otherwise, are a modern substitute for the extra-linguistic embrace of gems.) Stories of adulthood tend more often to lament a world of colour eclipsed by the shadow of language; they present images of luminous childhood becoming clouded by the habits of adult life. Elizabeth Barrett Browning: 'Frequent tears have run the colours from my life.'[9] Or Faber Birren, author of *Color and Human Response*: 'Youngsters are more responsive to color than to form and will delight in it through sheer pleasure. As they grow older and become less impulsive, as they submit to discipline, color may lose some of its intrinsic appeal.'[10] The most melancholy tale of colour-loss is told by Søren Kierkegaard in *Either/Or*:

How strangely sad I felt on seeing a poor man shuffling through the streets in a rather worn-out, light yellowish-green coat. I was sorry for him, but the thing that moved me most was that the colour of his coat so vividly reminded me of my first childish productions in the noble art of painting. This colour was precisely one of my vital hues. Is it not sad that these colour mixtures, which I still think of with so much pleasure, are found nowhere in life; the whole world thinks them harsh, bizarre . . . And I, who always painted my heroes with this never-to-be-forgotten yellowish-green colouring on their coats! And is this not so with all the mingled colours of childhood? The hues that life once had gradually became too strong, too harsh, for our dim eyes.[11]

The irony for Kierkegaard, and the pathos of the story, is that the yellowish-green colour he once painted his dashing heroes now turns up only on someone too poor to participate in the exercise of taste, someone excluded from the more refined discriminations and choices of culture. It is not that the poor man's eyes are less dim than ours. Rather, he has to suffer the humiliation of an incongruous brightness that would seem in absolute contrast with the rest of his dull and shuffling existence. He must wear the coat as a yellowish-green sign of his exclusion and failures. But then again, maybe it's not quite that straightforward. Maybe the poor man is able, in his exclusion from culture, to remain in colour in a way that the sophisticated Kierkegaard can only dimly recall, can now only experience in terms of something that life once had but has long since lost. Whichever way we decide to have it, the poor man is nevertheless marked by colour; whether he wants it or not, he wears a yellowish-green coat of otherness.

If in many of these stories the exposure to language robs a life of its colour, are there then other stories in which it happens the other way around? Are there equal and opposite stories in which exposure to colour robs a life of its language, stories in which a sudden flood of colour renders

a speaker speechless? Not many, it seems, and perhaps for obvious reasons. But this does almost exactly happen in *Shock Corridor*. Emerging from his intense and violent colour-psychosis, the once-vain reporter suddenly finds himself quite unable to speak and thus, ironically, unable to utter the name of the murderer he has just discovered. At the end of the film, he is left sitting silently in the corner of a room in a catatonic state, and it is as if his exposure to colour has done this to him. In this movie an explicit relationship is made between the exposure to colour and the loss of language, but a similar relationship is at least implied in many of the other colour stories discussed so far. That is, in just about every encounter with intoxication, delirium, sleep, fainting spells and other lapses into unconsciousness that are the currency of these stories, there is also a story of being reduced to silence, a story in which the power of speech is lost, at least for a moment.

The idea that colour is beyond, beneath or in some other way at the limit of language has been expressed in a number of ways by a number of writers. At the beginning of *Colour and Culture*, John Gage refers briefly to 'the feeling that verbal language is incapable of defining the experience of colour'.[12] In *Color Codes*, Charles A. Riley notes that 'colour refuses to conform to schematic and verbal systems.'[13] For Stephen Melville, colour 'can . . . seem bottomlessly resistant to nomination, attaching itself absolutely to its own specificity . . .'[14] Dave Hickey notes that 'when colour signifies anything, it always signifies, as well, a respite from language and history.' And he recognizes the paradox: 'I already knew, of course, that the condition of being ravished by colour was probably my principal disability as a writer, since colour for a writer is, finally, less an attribute of language than a cure for it.' Leonard Shalin, in his study of art and physics, writes: 'Colour precedes words and antedates civilisation, connected as it is to the subterranean groundwaters of the archaic limbic system,' and he cites the case of the infant's ability to 'respond to brightly coloured objects long before they learn words . . .'[15] And Julia Kristeva,

reflecting on Giotto's frescos at the Arena Chapel in Padua, begins her tantalizing discussion of the artist's colour with the recognition that while 'semiological approaches consider painting a language,' they are limited insofar as 'they do not allow for an equivalent for colour within the elements of language identified by linguistics.'[16] She concludes that 'if ever it was fruitful, the language/painting analogy, when faced with the problem of colour, becomes untenable.'

Kristeva quickly dumps semiology for psychoanalysis, and in doing so she too brings the discussion of colour into realms with which we have become familiar: the unconscious, the extra-linguistic, the infantile, the non-self. If the terminology she employs is highly technical, her story of colour is in other respects not so different from Cézanne's (whose work she acknowledges), Huxley's or Dorothy's (whose work she doesn't mention). Colour, for Kristeva, is linked to 'subject/object indeterminacy', to a state before the self is formed in language, before the world is fully differentiated from the subject. And colour always exists as a disruption in the symbolic order, even when 'in a painting, colour is pulled from the unconscious into the symbolic order . . .' Colour is unique in art in that it 'escapes censorship; and the unconscious irrupts into a culturally coded pictorial distribution'. (There are echoes here of Yves Klein's words as well as his colours.) Consequently, 'the chromatic experience constitutes a menace to the "self".' Or, as Kristeva then puts it: 'Colour is the shattering of unity.' It is as if colour begins not just to interrupt the process of self-formation, but to throw it into reverse; it is as if colour serves to de-differentiate the self and de-form the world. In this, colour 'enjoys considerable freedom', and one of the terms Kristeva uses most often in respect of colour is 'escape'. Colour 'escapes censorship'. It is through colour that 'the subject escapes its alienation within a code . . . that it, as a conscious subject, accepts.' And it is through colour that (with Cézanne and others) 'Western painting began to escape' the regimes and hierarchies of Academic art. And of course, the idea

of an escape through or into colour is one way of describing just about all the stories we have looked at: escape from the West and from words; escape from Kansas and from concepts; escape from sanity and from the self; escape from angels, angles and architects.

For Jacqueline Lichtenstein, it is also the autonomy and irreducibility of colour, and in particular its irreducibility to language, that marks it out as suspect, deviant and dangerous. Colour is 'a pleasure that exceeds discursiveness. Like passion, the pleasure of *coloris* slips away from linguistic determination'.[17] And although the Academies of the West would have it otherwise, this does not indicate a deficiency in colour so much as the insufficiency and impotence of language:

> How can anyone speak of *coloris*? ... How can we name a pleasure that eludes all assignation? The defenders of painting's dignity as a liberal art have amply deplored this lack since the Renaissance: the emotion that overcomes the viewer – who is ravished by the charms of *coloris*, dazzled by the shimmering ornaments of the vision before him – always show up as a turbulence in the ability to express it. Surprised, arrested, seduced, the individual is further dispossessed of the powers of speech; his ruin involves the crumbling of all discursive modes, the sudden failing of language.

Silence. The silence that colour may provoke is a mark of its power and autonomy. Silence is how we have to voice our respect for that which moves us beyond language. 'Whereof we cannot speak, thereof we must remain silent', said Wittgenstein, who also saw in colour the outer limits of language. Silence is spoken by the body, through our gestures and postures. The body is one of the means by which we express ourselves when we run out of words. Colour is thus connected to the body in at least two ways: it is applied to the body as make-up, and it is allied with the body in its resistance to verbalization. Moreover, with make-up we

not only make our bodies more visible and vivid, we also make them more expressive and articulate.

We often confront the world with a wave rather than a word, by showing rather than saying. Pointing. Sampling. Picking things up and putting things down. Even our words betray our dependency on mute gestures of one kind or another: when we explain something, we 'point it out'; when something is explained, we 'grasp' it. How often, when it comes to colour – when, that is, we need for some reason to be specific about colour – do we revert to a gesture? How often do we find ourselves having to point to an example of a colour? Dulux, a division of Imperial Chemical Industries and one of the largest commercial paint manufacturers in England, ran a series of television advertisements to promote their extensive range of household colours. Significantly, they were silent films; there was no dialogue in the group of scenes that made up each of the short narratives. These were films about pointing. In one, a young woman was seen on a bus; a few rows in front of her sat a man wearing a bright yellow hooded sweatshirt. An idea silently spread over the woman's face; she manoeuvred to a seat directly behind the man. The next scene saw the man and the woman leaving the bus and walking off in different directions. It was raining, but the woman was smiling and seemed so happy that she didn't notice – unlike the man, who hunched his shoulders and put his hood up to keep the rain off. As he did so, he revealed (to us but not to himself) a mini-disc-sized hole in the top of his hood. The woman, meanwhile, had gone into a hardware shop and was showing the bright yellow mini-disc of sweatshirt to the man at the counter. The final scene showed the woman back in her flat (happy, of course, but now it was getting irritating), painting the room the bright yellow sweatshirt colour.

A second version of the advertisement showed a pair of pale lavender underpants on a washing line. We saw the underpants as they were stolen by a lone anoraked figure . . . and we ended up in a pale lavender front room. The same point was being made, obviously enough. But beneath

the commercial drive of its surface narrative, the stories of the yellow shirt and lavender underpants were also philosophical tales about the inadequacy of words. They asked how it is possible for us accurately to represent colours to each other, when verbal language has proved itself entirely insufficient. And they suggested that, almost automatically, we reach outside language with the help of a gesture. We point, sample and show rather than say. And in our pointing, sampling and showing we make comparisons. In doing this, we call for the help of something outside ourselves and outside language, and in the process we expose the limits of our words. However complex and sophisticated our powers of description, these films tell us that they are no match for the greater complexities of the world and of colour.

Pointing and sampling, in this context, are quite alike. When we point to something over there, we acknowledge that that something is beyond both our reach and our words. When we sample something, we bring it within reach, but it can remain beyond words. Otherwise, we could describe it and wouldn't need to steal it. The silent story of the lavender underpants, and all stories like it, are stories about the difference between saying and showing. In a world dominated by the power of language, we often underestimate the significance of showing. And equally, we underestimate how often we resort to pointing. It has been argued that all attempts to explain something verbally will end up, at some point, with an index finger.

To fall into colour is to run out of words. This is the kind of sentence that should be found at the end of a chapter or book, not in the middle. But there are other ways in which words fail us when it comes to colour, and so there are still reasons to continue. We have to shift the ground a bit, however, and begin to talk less of 'colour' and more of 'colours'. What is the difference? If colour is single and colours are many, how can we have both? Plotinus said colour is 'devoid of parts', and this is probably among the most significant things ever said on the subject.[18] For Plotinus,

then, colour was single; it was indivisible. But in being indivisible, colour also put itself beyond the reach of rational analysis – and this was exactly his point. To analyze, after all, is to divide. If colour is indivisible, a continuum, what sense can there be in talking of colours? None, obviously . . . except that we do it all the time. Colour spreads flows bleeds stains floods soaks seeps merges. It does not segment or subdivide. Colour is fluid. Barthes thought so, and that is how it appears in *Shock Corridor*. Colour is indivisibly fluid. It has no inner divisions – and no outer form. But how can we describe that which has no inner divisions and no outer form, like a fog seen from within?

Colour may be a continuum, but the continuum is continuously broken, the indivisible endlessly divided. Colour is formless but ever formed into patterns and shapes. From at least the time of Newton, colour has been subjected to the discipline of geometry, ordered into an endless variety of colour circles, triangles, stars, cubes, cylinders or spheres. These shapes always contain divisions, and these divisions, as often as not, contain words. And with these words, colour becomes colours. But what does it mean to divide colour into colours? Where do the divisions occur? Is it possible that these divisions are somehow internal to colour, that they form a part of the nature of colour? Or are they imposed on colour by the conventions of language and culture?

This is tricky. Colour has become colours in numerous different ways, and its division has occurred in the service of numerous different purposes. In fact, there are two principal and common ways in which we divide colour. One is verbal and the other visual. On the one hand are the basic colour terms we all learn as children and use everyday. On the other hand are the basic colours, or primary colours, we also learn at school and use to produce other colours. These two and apparently simple ways of slicing up the colour continuum are quite separate; they belong to different domains but are easily confused, not least because the list of primary colours often overlaps with the list of basic colour terms.

'Colour has not yet been named', said Derrida. Perhaps not, but some colours have. We have colour names, and so we have colours. But how many? A great many more than we can name, to be sure. The human brain can distinguish minute variations in colour; it has been said that we can recognize several million different colours. At the same time, in contemporary English, there are just eleven general colour names in common usage: black, white, red, yellow, green, blue, brown, purple, pink, orange, grey. A lot has been said about these. They coincide with the hypothesis, put forward by the anthropologists Brent Berlin and Paul Kay in 1969, that all natural languages have between two and eleven basic colour terms. Furthermore, the Berlin-Kay hypothesis maintains that there is a consistent hierarchy within these terms: if a language has only two colour terms, they will be black and white; if it has three colour terms, they will be black, white and red; if it has four colour terms, they will be black, white, red and yellow or green; if it has five colour terms, it will include both yellow and green; and so on through blue and brown until purple, pink, orange and grey, for which Berlin and Kay found no consistent hierarchy in their test results.

The first thing to note about these eleven terms is that they constitute a rather irregular group. It combines several different types of colour: the achromatic black, white and grey; the spectrum colours red, orange, yellow, green, blue and purple; and the non-spectrum colours pink and brown. Grey, pink and brown are distinct in that each can be described in terms of mixtures of other colours: a pale or whitish red, a kind of darkish yellow, etc. Black and white are distinct insofar as they are considered opposites, whereas only relatively technical colour usage treats, say, orange as the opposite of blue. Black and white also tend to be thought of as singular colours, as absolutes, as two end-points between which lies a sea of grey. (Thus the simultaneous experience of two different whites – when, say, we see a sheet of white paper come into contact with a white desktop – seems a little disruptive, and we want to know which of these

whites is *really* white.) However, for all their dissimilarities, when put next to other common English colour terms – 'mauve', 'scarlet', 'beige', 'turquoise' and so forth – it is clear that the Berlin-Kay terms do seem somehow more basic: they are less specialized and, for the most part, less easy to rephrase in terms of combinations of other colours.

There seems to be no obvious reason not to go along with the idea of basic colour terms. This does not mean, however, that we necessarily have to go along with the idea of basic colours. The linguist John Lyons has summarized and developed some of the criticisms that have been made of the Berlin-Kay hypothesis, although he contends that the main problem lies not with the hypothesis itself but with careless popularizations of it.[19] Much of Lyons's critique is developed using the example of Hanunoo, a Malayo-Polynesian language, although he also shows that you don't have to travel very far to find other anomalies. Literary Welsh, for example, has no words that correspond exactly with the English 'green', 'blue', 'grey' or 'brown'; Vietnamese and Korean make no clear distinction between green and blue; and Russian has no single word for blue, but two words denoting different colours. Then there is purple. Newton had a problem with it, which we will return to, and so do the French, as they also do with brown. *Violet* and *brun* are both basic colour terms in French, a language which, like English, also scores the full eleven on the Berlin-Kay scale. But if the French *violet* corresponds to our 'violet', it would seem that it is not quite the same as our purple. Likewise, their *brun* might more or less correspond to our 'brown', at least in the abstract, as a colour term; but when used descriptively rather than referentially, when applied to things in the world like shoes, hair and eyes, brown and *brun* part company. French shoes may be brown, but they aren't *brun* so much as *marron*. And French hair, if it's *brun*, is dark rather than brown.

Derek Jarman: 'This morning I met a friend on the corner of Oxford Street. He was wearing a beautiful yellow coat. I remarked on it. He had bought it in Tokyo and he said that it was sold to him as green.'[20]

If French basic colour terms appear not to have exactly the same basis as English basic colour terms, it is as nothing compared to Hanunoo. This language has four basic and rather broad colour terms, which nevertheless correspond in their focal points to our black, white, red and green. It is thus consistent with the Berlin-Kay hypothesis. So far so good. However, citing the research of the anthropologist Harold Conklin, Lyons points out that chromatic variation does not in fact seem to be the basis for differentiation between the four terms. Rather, 'the two principal dimensions of variation are lightness versus darkness, on the one hand, and, on the other, wetness versus dryness, or freshness (succulence) versus desiccation.' This sounds odd; it requires some effort of the imagination to picture a language that makes no essential distinction between colour and texture or, more specifically, between variations of colour and degrees of freshness. Or does it?

Perhaps from time to time we all speak Hanunoo. Certainly, there are artists and even the occasional philosopher for whom there is nothing at all strange about it. Hokusai, for example: 'There is a black which is old and a black which is fresh.'[21] Or Ad Reinhardt: 'Matte black in art is / not matte black; / Gloss black in art is gloss black / Black is not absolute; / There are many different blacks . . .'[22] Or Wittgenstein: 'Mightn't shiny black and matt black have different colour names?'[23] Or Adrian Stokes: 'An object is red or yellow, on the one hand, on the other it shines, glitters, sparkles.'[24]

For Lyons, the lesson of Hanunoo and other languages is that colour names are so tied into cultural usage of one kind or another that any abstract equivalence is effectively lost. In some cases, they cease to be colour names in the ordinary sense. To conceive of colour in terms independent of, say, luminosity or reflectiveness is in itself a cultural and linguistic habit and not a universal occurrence. Ditto the separation of hue from tone. Indeed, Hanunoo and other languages have no independent word for 'colour' at all. Such basic colour terms as we have, to put it another way, even terms like 'colour', are the products of language and

culture more than the products of colour. Lyons: 'I am assuming . . . that colour is real. I am not assuming, however, that colours are real. On the contrary, the main burden of my argument is that they are not: my thesis is that they are the product of the lexical and grammatical structure of particular languages.' A similar argument is made by Umberto Eco in his essay 'How Culture Conditions the Colours We See'. He too brings on Hanunoo and, like Lyons, uses it to help account for the perceived lack of fit between the colour terms of different languages, such as Latin and ancient Greek, and of our own. He concludes that in these languages 'the names of colours, in themselves, have no precise chromatic content: they must be viewed within the general context of many interacting semiotic systems.'[25]

Russian, we are told, has two words for blue. That is to say, Russians appear to deal with blue in roughly the way we deal with red and pink. Certainly, what we call light blue is optically as distinct from dark blue as pink is from red, perhaps more so, and yet our language allows no such independence for bits of blue. 'Pink' is the only basic colour term in English that also denotes a specific part of another basic colour term, one end of 'red'. But there seems to be no necessary reason for this in terms of our experience of colour. When we see light blue, do we see something different from what a Russian speaker sees? And while we are on the subject of light and dark, what about dark yellow? Yellow is certainly the lightest of the spectrum colours, but when yellow is darkened, where does it go? Does it get wrapped up in a kind of brown? Or is it lost to the insecure empire of orange? And if we can just about imagine yellow drifting and darkening towards orange and brown, why can't we imagine it turning towards green in the same way? What happens to yellow as it travels towards green? And how distinct is green from yellow? More distinct than orange is from yellow and purple is from blue and from red? Probably, but then why don't we have a name or names for the colour-space between green and yellow?

Imagine a rectangular grid made up of 320 equal units, 40 wide and

8 high.[26] Each unit is a single flat colour. The whole grid is arranged from right to left like a spectrum. From top to bottom, there are eight steps of tonal variation from near-white to near-black. A series of irregular four- or five-sided shapes is placed over the grid in different positions, like mini-continents on a map. Each shape represents the extent of the focal point of a Berlin-Kay basic colour term, as selected by speakers of twenty different languages. The shapes representing yellow, orange, red and brown are quite small, covering on average only four or five units of the grid. The shapes representing green, blue and purple, on the other hand, are much bigger, covering twelve to eighteen units. (Pink is somewhere between the two; black and white are each concentrated on a single unit, as might be expected.) This suggests that there is a high level of agreement among different speakers as to the focus of yellow, orange and red, but much less general agreement as to what constitute the foci of other colours. There are two other features of this map that are worth noting. First, these mini-continents occupy in total less than a third of the map's overall surface, indicating that an enormous range of colours are thought of as composite, or are simply not thought of very much at all. Second, while most of the colour-continents have only narrow channels between them, there is a much larger uncharted area between yellow and green. Curiously, it is in this area, in this sea of yellowish-green, that Kierkegaard found his tramp and Jarman's friend bought his coat. For the philosopher C. L. Hardin, author of one of the most comprehensive and rigorous studies of the science of colour, this gap, this nameless colour between yellow and green, remains an anomaly (as does the entire existence of pink, incidentally). Nevertheless, he offers a tentative and, for a philosopher-scientist, a rather weird explanation for this space: he thinks it is not a very nice colour, or that people tend not to like it, so nobody has bothered to name it.

Wittgenstein asked: 'How do I know this colour is red?' To which he replied: '. . . because I have learned English.'[27] To put it another way: How

do I know this is *mabi:ru*? Because I have learned Hanunoo. William Gass on the relationship between colour names and colours, starting with blue:

The word itself has another colour. It's not a word with any resonance, although the *e* was once pronounced. There is only a bump now between *b* and *l*, the relief at the end, the whew. It hasn't the sly turn which crimson takes halfway through, yellow's deceptive jelly, or the rolled down sound in brown. It hasn't violet's rapid sexual shudder, or like a rough road the irregularity of ultramarine, the low puddle in mauve like a pancake covered with cream, the disapproving purse to pink, the assertive brevity of red, the whine of green.[28]

Gass acknowledges his debt to the pigmented letters of Arthur Rimbaud: 'I invented the colour of vowels! – *A* black, *E* white, *I* red, *O* blue, *U* green.'[29] And how did Rimbaud know *I* was red? Because he had learned French, presumably.

This is confusing. To discuss colour terms is, it seems, to talk about language more than it is to talk about colour. Basic colour terms may be universal, but they are also mainly useless when it comes to the study of colour. Gass's beloved blue is everywhere, and everywhere it is different. The word *blue* holds the entire disorganized and antagonistic mass of blues in a prim four-lettered cage. His essay is a wonderful drunken tumble into the chaos of the colour. It *is* confusing. But the other common way of dividing up colour into colours – the slicing up of the spectrum into bands or wedges and the further division of these shapes into primaries and secondaries – is no less confusing. 'Light itself is a heterogeneous mixture of differently refrangible rays', noted Isaac Newton in 1665, in the middle of a remarkable century which provided much of our modern understanding of optics.[30] Newton wasn't alone in his investigation of the properties of light: the law of refraction had been discovered nearly 50 years earlier by Willebrand van Snel van Royen, and the same law

had been formulated independently by René Descartes, whose 'Origin of Rainbows' had published in 1637. If, with Pierre de Fermat, these scientist-philosophers provided the first clear outlines of a systematic theory of light, Newton's great contribution – at the age of 22 – was to colour it in.

When Newton refracted white light through a glass prism and produced a coloured spectrum, he was doing science. But when he divided the result into seven distinct colours, what we now call the colours of the rainbow, he was doing something else. Red, orange, yellow, green, blue, indigo, violet: there is something wrong with the tail end of the list; it doesn't sound quite right; it's confusing, to children, adults and Berlin-Kay alike. Either Newton's English had a different set of basic colour terms or something else was at stake. In fact, it is known that Newton had a strong interest in musical harmonies, and that he divided the spectrum into seven colours in order to make it correspond to the seven distinct notes in the musical scale. For Charles Blanc, it made more sense to divide God's palette into six colours, as it did for the designer of the Apple Computer logo, whose partially eaten spectrum gazes at me every time I sit down to write. The spectral Apple has horizontal bands which begin with green at the top and end with blue; when Ellsworth Kelly made a series of multi-panel paintings entitled *Spectrum*, he used thirteen vertical bands with a (different) yellow at each end. The highly observant John Constable, on the other hand, often settled for a three-colour spectrum in red, white and blue rainbows. Newton, as John Gage has noted, thought of settling for five colours; painting from the medieval period and since has represented the spectrum sometimes in two colours, sometimes in four, sometimes in more. For me, the rainbow spreads its colour evenly at both edges but has a kink in the middle, where yellow meets green, where Kierkegaard met his tramp, where colour has no name.

The rainbow is a universally observable and consistent natural phenomenon, and yet its representations, both verbal and visual, are strikingly inconsistent. Rainbows are always seen through the prism of

a culture; they are marked by habits of language or the conventions of painting. Kelly's spectrum and the Apple spectrum are highly schematic; they reduce a great undivided analogical sweep to six or thirteen discrete units. These units are not necessarily named, but they are isolated from one another. They relate to a system. Newton did more than name the colours of the rainbow. He also took the band of differently refrangible rays and joined up the two ends. In doing this, he made the first colour circle, the first diagram of colour and colours. It is brilliant, concise and in many ways very practical. At least, a later, tidied-up, more symmetrical version of Newton's colour circle has been immensely useful. This is the six-colour colour circle, the one based on the three primaries, red, yellow and blue; the one passed down in art classes throughout the West. It's useful for painters or, at least, for some painters, some of the time. But this particular colour circle is not much use to printers, or to those who mix their colours through the cathode-ray tube, or to those who work the paint-mixing machines in hardware shops. The printers' primaries are yellow, cyan, magenta and black; televisions mix red, green and blue light; the colour circle of commercial paints has four effective primaries in red, yellow, blue and green. We have different primaries for different jobs; different primary colours for different types of painting; primary colours for mixing inks and for mixing light.

In the same way as there are basic colour terms there are basic colours. They are universal – but they are also contingent. Colour is universal, and colours are contingent. Is that right? The world is colour, and it is full of colours. We see in colour, and we see colours. Colour is nature, and colours are culture. Colour is analogical, and colours are digital. Colour is a curve, and colours are points on that curve. Or colour is a wheel, and colours are the infinite and infinitely thin spokes inserted in the wheel. These spokes, rotated in another dimension, *Flatland*-like, become planes (as on a Rolodex), those flat areas of individual colour that we see around us all the time. These may be bad analogies, but there aren't any good

ones. And it doesn't really matter anyway, as we seem to get by. Colour is Dionysiac, and colours are Apolline. How does that sound? Colour is Nietzschian 'primal oneness' and colours are the 'principal of individuation'. This at least doesn't sound too distant from the ways in which Cézanne, Corb, Huxley and Kristeva wrote about colour.

Colour is in everything, but it is also independent of everything. Or it promises or threatens independence. Or is it the case that the more we treat colour as independent, the more we become aware of its dependence on materials and surfaces; the more we treat colour in combination with actual materials and surfaces, the more its distinctiveness becomes apparent? There is a belief that objects would somehow remain unchanged in substance if their colour was removed; in that sense, colour is secondary. I might just as easily say that colours remain the same even when objects are removed; in that sense, colour is primary. When colour is more than tinted chiaroscuro, when it is vivid, it is also autonomous. It separates itself from the object; it has its own life. That car may happen to be bright yellow, but no more than that bright yellow may happen to be a car. I can imagine the car another colour, but no more than I can imagine the yellow another shape. William Gass again: '. . . shape is the distance colour goes securely.' And: '. . . every colour is a completed presence in the world, a recognisable being apart from any object.' Stephen Melville again: 'We . . . know colour only as everywhere bounded . . . But colour repeatedly breaks free of or refuses such constraint . . .'[31]

Chromophilia

I was expecting to write a book about art, if only because most other things I have written have been about art, and one would think there is a lot to say about art in a book about colour. It just hasn't turned out that way. The more I have written, the more the art has got pushed further and further back. I have mentioned at least as much literature, philosophy and science as art theory, and I have said much more about films, architecture and advertisements than painting or sculpture. Fair enough: colour is interdisciplinary. Except that I feel uncomfortable casually passing something off as 'interdisciplinary'. I want to preserve the strangeness of colour; its otherness is what counts, not the commodification of otherness. The interdisciplinary is often the antidisciplinary made safe. Colour is antidisciplinary.

Art criticism has occasionally ventured into the arena of colour, and it has done so under a variety of guises – formalist, idealist and so on. As often as not, it has become caught in a thicket of inadequate words, and this is not entirely surprising. Depending on whether the aim is objectively to describe a particular passage of colour, or subjectively to express its

effect on the viewer, words tend to appear either too laboured or too breathless. The obvious thing to say is that colour speaks silently for itself in art, and that any attempt to speak on its behalf is bound to fail. And yet for all the small talk that might happily be silenced forever, there is at the same time a bigger silence around the very subject of colour in art which itself speaks volumes.

Just about all the vividly coloured art I have mentioned was either made in the 1960s or had its genesis in that period. And most of it is not really painting, even if it is painted and fixed to a wall. None of it is oil painting or made with artists' colours. Warhol used canvases but covered them in screen-printers' inks; Klein used rigid panels to which he attached sponges and other things; Judd and Flavin made 'three-dimensional work'. There were precedents of a kind for this in the work of Robert Rauschenberg, Jasper Johns and Frank Stella, but only Stella did much with colour. In sculpture, there was David Smith and then Anthony Caro.

This is what I want to argue: that something important happened to colour in art in the 1960s. On the one hand, many painters continued to use artists' colours, call themselves colourists and have at their disposal an established language of colour in painting. Push and pull, hot and cold, that sort of thing. On the other hand, an entirely distinct and unre-lated use of colour occurs in the work of those artists who were identified, for the most part, with the emergence of Pop art and Minimalism. This was an entirely new conception of colour, and it was put into words, tentatively, by Stella, during a 1964 radio interview, when he said: 'I knew a wise-guy who used to make fun of my painting, but he didn't like the Abstract Expressionists either. He said they would be good painters if they could only keep the paint as good as it is in the can. And that's what I tried to do. I tried to keep the paint as good as it was in the can.'[1]

'To keep the paint as good as it was in the can'. It's a simple enough phrase on the face of it: direct, unambiguous, deadpan and not unlike Stella's paintings themselves of the time. But it's also a phrase which,

behind its flat tones, carries a kind of resonance. It acknowledges that something important had changed in art. And, as it does so, it also betrays a kind of anxiety. The change in art it acknowledges may not seem so big: it says that paint now came from a can. That is, from a can rather than from a tube: whereas artists' paints usually come in tubes, industrial or household paints are normally stored in cans. Artists' paints were developed to allow the representation of various kinds of bodies in different types of space. 'Flesh was the reason oil painting was invented', said De Kooning. Industrial paints are made to cover large surfaces in a uniform layer of flat colour. They form a skin, but they do not suggest flesh. They are for paint-jobs more than for painting-proper. They are different technologies harnessed to different worlds: in short, to use paint from a can rather than from a tube may not seem much, but it carries with it the risk – or the promise – of abandoning the entire tradition of easel painting, of painting as representation. If this idea, and this risk, were hinted at in Europe with Dada and Constructivism, they were again taken up after the war by Pollock, and in the early 1950s by Rauschenberg. By the time Stella had said his piece, a generation of artists was trying out a range of more-or-less recently developed industrial paints, finishes, supports and other materials.

Not only did this type of paint come in a can, it looked *good* in the can.

The anxiety that Stella's remark betrays does not, or at least does not directly, concern the loss of three or more centuries of oil and easel painting. He was pointing in another direction. His concern was not how his work would measure up to the past of art but how it would compare with the paint in the can. He 'tried to keep it as good as it was in the can', but he knew he might not succeed. If he didn't keep it as good . . . what was at stake? Again, it may not sound like much, but in a way it was perhaps almost everything that mattered at the time. Twenty years earlier, it couldn't have been said – or at least it wouldn't have meant anything very much. But by the early 1960s, Stella's concern had come to stand

for something quite critical in the relationship of art with the wider world in which it was situated. That Stella sought to 'keep' the paint that 'good' suggests that he knew it might be hard to improve on the materials in their raw state, that once the paint had been put to use in art, it might well be less interesting than when it was 'in the can'. This is the anxiety he described: the anxiety that the materials of the modern world might be more interesting than anything that could be done with them in a studio, and the more you did to them the less interesting they might become. This is an entirely modern anxiety, an unforeseen consequence, perhaps, of the nineteenth-century project to paint the dramas and details of modern life – from its billowing chimneys down to its shiny patent-leather shoes. It's an anxiety that has continued to haunt artists ever since. But it is also a promise.

Much painting since the 1960s is related in its evasion of oil paint and, more to the point, in its evasion of the protocols and procedures, conventions, habits of thought, training, techniques, tools, effects, surfaces and smells that went with it. Why? What motivated this turn by artists against a technology which had been developed, over three hundred years or so, exclusively for the use of artists? There may be any number of answers to this question. There is an argument – one that was very prominent around the time of Stella's remark – that in order to survive, continue and develop, painting has to distinguish itself from all the other arts and equally from all that is not art. But the evidence of many artists' work at the time and since suggests something like the opposite has happened. That is, painting has been continued by constantly being tested against that which stands outside painting-as-art: the photograph, the written word, decoration, literalness or objecthood. In other words, painting has been continued by being continuously corrupted: by being made impure rather than pure; by being made ambiguous, uncertain and unstable; and by not limiting itself to its own competences. Painting has been kept going by embracing rather than resisting that which might

extinguish it, and this has included embracing the possibility of painting becoming all but indistinguishable from a paint-job. It has also included the possibility of paintings becoming all but indistinguishable from objects, photographs, texts and so forth. But while painting has shown itself to be capable of absorbing these things, it is always equally possible that painting itself might be absorbed *by* them. That is to say, it is a story of the corruption of painting as the continuation of painting, but one that has no guarantee of a happy end, because the corruption of painting must also contain the real possibility of the cancellation of painting. Paint itself is one of the characters in the story. Perhaps one of the differences between a painting and something merely painted is – or, for a while, was – the difference between types of paint. Perhaps artists' colours and materials were art's guarantee, a kind of certainty, art's pedigree in a universe of aliens, impostors and mongrels, its received pronunciation in a world of strange and irregular voices. Perhaps this was the attraction of commercial paints: they seemed to contain the possibility for both the continuation and the cancellation of painting. And perhaps that is why they looked so good in the can.

Adorno wrote in *Aesthetic Theory*: 'At the present time significant modern art is entirely unimportant in a society that only tolerates it. This situation affects art itself, causing it to bear the marks of indifference: there is the disturbing sense that this art might as well be different or might not exist at all.' And: 'Aesthetics, or what is left of it . . . can no longer rely on art as a fact. If art is to remain faithful to its concept it must pass over into anti-art, or it must develop a sense of self-doubt that is born of the moral gap between its continued existence and mankind's catastrophes, past and future.'[2] Adorno's remarks were published a couple of years before Stella said his piece on the radio. I can't imagine that they knew anything about each other, but the two sets of remarks have something in common. They were spoken with different voices, among different contemporaries and to different audiences, but they say something similar

about the importance, or the unavoidability, of doubt. Both suggest that art, to continue, might somehow have to register the possibility of its non-existence within itself. Adorno offered a theory for why that might be the case; Stella offered a practical interpretation of the problem, a way of carrying on, a means for maintaining and perhaps renewing the self-doubt which, for Adorno, marked art as modern.

Not pure art, but not the end of art, either. Not elevated, detached and exclusive, but not the 'sublation of art into the praxis of life'. Rather, something between these absolutes, something less certain of its self and of its place in the world. Not the theory that all the arts must resist or suppress the influence of every other art, that every art must distance itself from all that is non-art and that only then can value be preserved. But equally, not the demand for the dissolution of the arts into one another, for a merging or blurring of the boundaries between art and life. While both these theories can, in some part, be connected with Adorno's reflections, what he seems also to have been suggesting is that there may be a productive space between these absolutist alternatives, a space in which art walks on a kind of tightrope between exclusivity and extinction. The work that occupies this space could be seen to perform a balancing act which involves both taking on that which threatens the 'purity' of art and holding off the moment of its dissolution. This drama involves embracing that which implies your extinction and yet refusing to be extinguished. What has often resulted is neither 'pure' art nor the withering away of art or, more to the point here, neither 'pure' painting nor the withering away of painting. It is often a kind of hybrid, something not quite painting, yet not entirely something else either.

We have already come across an argument for the moral force of corruption in Des Esseintes' tirade against 'pure' Latin. Rather differently stated, again, but a similar theme nonetheless: corruption as continuation and renewal. This is a theme that has never been far from our discussion of colour: corruption is a part of the definition of chromophobia. Then

there is the other great modern philosopher of corruption and renewal, Mikhail Bakhtin. (Bakhtin, it should never be forgotten, smoked one of his own books. This may not be entirely relevant, but it is still a very good story. At some point in Russia during World War II, after a bomb had destroyed the publishing house containing one of his manuscripts, Bakhtin ran out of cigarette papers – but not of tobacco. You have to picture it: there was this tobacco, but no means to smoke it; there was this manuscript, and no obvious means to publish it. What would *you* have done?)

Bakhtin formulated his thesis of corruption and renewal in a number of related ways: through his theory of language, in his theory of the novel and in his discussion of Rabelais and the concept of carnival. All were characterized as unstable, dynamic and mutable, subject to complex and often antagonistic tensions. Any given language was, for Bakhtin, always being pulled in different directions, spoken in multiple voices; it was both official and idiomatic, received pronunciation and slang. This 'hetero-glossia' was clearly similar to Des Esseintes' idea of the process of linguistic renewal. Likewise, for Bakhtin, the importance of Dostoevsky was in his invention of the 'polyphonic' novel which admits no final unified voice to speak above all the others.

It was in *Rabelais and His World* that Bakhtin elaborated his great theory of corruption (or degradation) and renewal. For Simon Dentith, the book 'articulates an aesthetic which celebrates the anarchic, body-based and grotesque elements of popular culture, and seeks to mobilise them against the humourless seriousness of official culture'.[3] It is here that Bakhtin articulated his distinction between the 'grotesque body' and the 'classical body' which seemed oddly appropriate to the discussion of a certain recent building interior. For Bakhtin, carnival was a great, if temporary, upturning. A dethroning, a usurping of the official by the unofficial, a corruption of the refined by the vulgar. And it was laughter, all the loud, riotous laughter that went with seeing the powerful and the

pompous get their come-uppance. Laughter is many things, of course; it is, among other things, a wordless language spoken by the body when our standard vocabularies desert us. Carnival is the Fall as comedy. For Baudelaire, writing in 'The Essence of Laughter', it was 'certain that human laughter is intimately connected with the accident of an ancient fall, of a physical and moral degradation'. But, at the same time, in this Fall there was also always a renewal, a renewal found, as Bakhtin put it, in laughter's 'indissoluble and essential relation to freedom'.[4]

Bakhtin did not connect carnival to colour, but Kristeva did when she described Giotto's colours as 'the visual precursors of the earthy laugh that Rabelais only translated into language a few centuries later'.[5] And she went on to make this connection with Bakhtin (and, in the process, with Barthes) more explicit:

> Giotto's joy is the sublimated jouissance of a subject liberating himself from the transcendental dominion of One Meaning (white) . . . Giotto's joy burst into the chromatic clashes and harmonies that guided and dominated the architectonics of the Arena Chapel frescoes . . . This joy evokes the carnivalesque excess of the masses . . .

But we need to get back to the chromatic clashes of our own age, back to contemporary colour in modern form. And this means getting back, at least for a moment, to some of the differences between colour that comes out of a can and colour that comes out of a tube.

Sooner or later, an artist who uses commercial or industrial paints is bound to notice the vast range of other colours which are on offer at the touch of a button – there are about two thousand available in the standard computerized mixing systems. At the heart of this system – although in an important sense this system is entirely heartless – lies a small strip of paper with a few rectangular swatches of colour printed on it: the colour chart, a disposable list of readymade colour. Each strip of paper

is a perfect abstract painting in miniature, or a compact example of colour serialism or one page of a vast *catalogue raisonné* of monochromes. The colour chart is to commercial colours what the colour circle is to artists' colours. Artists' colours are connected to the palette; the palette is connected to colour mixture; colour mixture is connected to colour theory; colour theory is connected to the colour circle. The colour circle has dominated the understanding and use of colour in art. Based on a geometry of triangulation and a grammar of complementarity, the colour circle establishes relationships between colours and also implies an almost feudal hierarchy among colours – primaries, secondaries and tertiaries, the pure and the less pure. The colour chart offers an escape from all that. It is, in effect, simply a list, a grammarless accumulation of colour units. In the colour chart, every colour is equivalent to and independent of every other colour. There are no hierarchies, only random colour events. The colour chart divorces colour from conventional colour theory and turns every colour into a readymade. It promises autonomy for colour; in fact, it offers three distinct but related types of autonomy: that of each colour from every other colour, that of colour from the dictates of colour theory and that of colour from the register of representation.

The colour-chart colours have contributed to a further change in the use and understanding of colour. This might be called the digitalization of colour, whose opposite is analogical colour. The colour circle is analogical; the colour chart is digital. Analogical colour is a continuum, a seamless spectrum, an undivided whole, a merging of one colour into another. Digital colour is individuated; it comes in discrete units; there is no mergence or modulation; there are only boundaries, steps and edges. Analogical colour is colour; digital colour is colours. The postwar period was the period of the digitalization of colour in art. Rauschenberg's monochromes, Warhol's screen prints, Richter's colour-chart paintings, Halley's cells and conduits all participated in this process in different ways. Even painters who continued to use artists' colours – such as

Kenneth Noland or Ellsworth Kelly – still participated in the differentiation of colour. It is not that digital colour is more true than analogical colour. But it may be true that digitalized colours have a stronger relationship with works of art that refer, directly or indirectly, to the experience of modernity. These colours are more the colours of things than atmospheres. More urban colours than the colours of nature. Artificial colours, city colours, industrial colours. Colours that are consistent with the images, materials and forms of an urban, industrial art.

The step between the colour circle and the colour chart, between artists' paints and commercial paints, is probably greater than that between commercial paints and a range of other coloured light-industrial materials, such as plastics, metals and lights. Judd said: 'Other than the spectrum, there is no pure colour. It always occurs on a surface which has no texture or which has a texture or which is beneath a transparent surface.'[6] (Judd also spoke Hanunoo.) And Judd, together with most of his contemporaries, abandoned the spectrum, the pure unbroken continuum, for the more localized, contingent, materially and culturally specific colour event. In the process, they abandoned painting. Not paint, not colour applied to a surface, but painting as a technique practised in a studio by an artist. Judd again: 'The achievement of Pollock and the others meant that the century's development of colour could continue no further on a flat surface . . . Colour, to continue, had to occur in space.'

The kinds of materials that Judd and his contemporaries looked towards were, like paints in cans, also readymades and also available in a range of colours and finishes which were usually flat and often shiny. Flat and shiny: this is one of the paradoxical attractions of commercial paints and materials: the double quality of the dead and the dynamic, the bland and the brilliant. A shiny surface gives depth to flatness at the same time as it emphasizes that flatness. But it is a kind of depth which is entirely the opposite of the atmospheric depth of traditional easel painting. This is an inexpressive, mechanical depth. It is not psychological or emotional,

at least not in the traditional sense, not deep and not heavy. Indeed, any light-reflecting surface will always convey lightness (which is why mirrors can feel abnormally heavy when they are carried). A shiny surface also reflects not an imaginary inner world but an actual external space, the contingencies of the environment in which the work is situated: the viewer's space. But it is vivid, nonetheless. It is sharp, hard and live, in a vulgar kind of way, and its vulgar sharpness is part of its attraction.

Often flat and shiny, but always intense. The commercial colours themselves can often appear dull and insipid, but the surfaces and materials on or in which they sit, and their finishes, can give them a kind of intensity that is unavailable in most artists' colours. Warhol found that intensity, for the most part, in the opaque, saturated colours of screen-printers' inks, but he also used silver, gold, aluminium and diamond dust in his images and objects. Stella's early stripe paintings were made in a variety of enamel, aluminium, copper and fluorescent paints. At least one work was executed in shiny silver burglar-alarm tape. Lucio Fontana sometimes put glitter into his oil paints to give them a bright and kitschy reflectiveness. Klein also used gold leaf for some of his monochromes, but for the most part worked towards developing a deep matt intensity for his International Klein Blue. He complained bitterly about how the intensity of pigment was blunted by the medium of oil paint, and it took him many months to come up with a binder that would allow for the kind of colour saturation he was after – one that would begin to deform the shape and dislocate the surface of his supports. And one that would take him away from painting in the process; an invitation to an exhibition of Klein's work read: 'The monochrome propositions of Yves Klein secure the sculptural destiny of pure pigment today.'[7]

The other way to deform and dislocate is with something that reflects, or in some way projects, light or colour. Colour is excess, but colour in art is also the containment of excess. This is unavoidable. The analogical flow of mixed colours decreases the intensity of any particular hue; but

the intensity of hue provided by the digital colour also tends to localize that colour. Our awareness of its containment increases. Shiny begins to delocalize colour; it picks up other colours and redistributes its own. Translucent allows one colour to spill onto and overlap another and to glow a little. Fluorescent tubes and incandescent lights project light and colour indiscriminately onto every other surface within range. In these ways, the isolation of local colours is countered and put into reverse. Colour begins to regain its excessiveness.

Vulgar and sharp; commercial and contingent; intense, brash and impure. Impurism.

In 1965, Robert Smithson was drawn to a '"glowing" pink plexiglas box' which suggested 'a giant crystal from another planet'.[8] The maker of this box, Smithson discovered, shared his own interest in geology and mineralogy, so one day the two men went 'rock-hunting in New Jersey'. Smithson recounts some of the details of this excursion in his 1966 essay 'The Crystal Land': 'Upper Montclair quarry, also known as Osborne and Marsellis quarry or McDowell's quarry, is situated on Edgecliff Road, Upper Montclair, and was worked from about 1890 to 1918. A lump of lava in the centre of the quarry yields tiny quartz crystals. For about an hour Don and I chopped incessantly at the lump with hammer and chisel . . .' Don, of course, was Don Judd, and as they chiselled, Smithson looked across from the quarry towards the New Jersey suburbs and New York skyline:

> The terrain is flat and loaded with 'middle income' housing developments with names like Royal Garden Estates, Rolling Knolls Farm, Valley View Acres, Split-level Manor, Babbling Brook Ranch-Estates, Colonial Vista Homes – on and on they go, forming tiny boxlike arrangements. Most of the houses are painted white, but many are painted petal-pink, frosted mint, buttercup, fudge, rose beige, antique green, Cape Cod brown,

lilac, and so on. The highways crisscross through the towns and become man-made geological networks of concrete. In fact the entire landscape has a mineral presence. From the shiny chrome diners to glass windows of shopping centres, a sense of the crystalline prevails.

In his next published essay, 'Entropy and the New Monuments', Smithson argued that 'instead of being made of natural materials, such as marble, granite, or other kinds of rock, the new monuments are made of artificial materials, plastic, chrome, and electric light.' There's something of Huysmans in Smithson's praise of glowing colours and artificiality, but for the young American in the mid-'60s there was no need to build a hermetically sealed temple to sustain them. The 'new monuments' of Judd, Flavin, LeWitt and others occupied a space bordered by science fiction on the one side and the developing urban and suburban landscape on the other; you are left with a sense that these borders were being drawn closer together and becoming harder to distinguish from one another. Smithson saw something rare in this new work: the embrace in art of a colour-world which, in one way or another, existed far outside art and which, for some, could only mean the death of art. Smithson saw in the glowing pink plexiglas and fluorescent tubes of light what Stella had seen in the can of commercial paint: a promise often mistaken for a threat. And more: he saw in this colour a glimpse of another world or, rather, several other worlds: the past-present worlds of minerals and crystals, and the future-present worlds of science fiction. And these worlds, which in one sense are entirely remote and 'antipodean', were also echoed in the gleaming and glowing surfaces of the very un-other-worldly suburbs of New Jersey. Thus every chrome rail and flickering shop sign, every polished bar and plastic panel, contained both a glimpse of an unfathomable past and the flash of an as yet unformed future. (And the same could perhaps be said for Jacques Lacan's famous empty sardine can, which contained

'the ambiguity of jewels' as if floared on the ocean, glittering in the sun.)

The glowing-crystal-sci-fi-New-Jersey version of Minimalism is also almost a land of Oz – a 'Mr Wizard' even makes an appearance in the 'Crystal Land' – a land where colours and reflections disturb ontologies and deform objects. It is a land that is still there to be glimpsed in the flare of brilliant colour, be it in the surfaces and fragmented reflections of the street or in the art that finds a way of harnessing this immaterial material so that we may look at it a little more closely and for a little longer. And even though the shiny chromophile 'monuments' of Minimalism and Pop were quickly followed by largely unshiny and chromophobic Conceptual art, contemporary versions of the ruby slippers can occasionally be seen, whether in strings of shiny coloured plastic, in the glow of coloured lights, in the sparkle of an LED display board, in the polished surfaces of stainless steel or in the lustre of metallic paints.

Not everyone has been as interested in and impressed by the impure colours and sharp finishes of the contemporary urban environment. Rather the opposite. Even for many who have maintained a strong interest in colour, its perceived proximity to popular culture or mass culture, its association with kitsch and artificiality, has remained a major problem. For these commentators, the feminine, oriental, infantile and narcotic aspects of colour have often been a part of its attraction, but its popular, vulgar and commercial associations have been altogether less appealing. Huxley, for example, discussed at length how the sparkle of modern materials was a devaluation of the transcendent glitter of precious stones: 'We have seen too much pure, bright colour at Woolworth's to find it intrinsically transporting.'[9] And he continued:

Modern technology has had the same devaluating effect on glass and metal as it had on the fairy lamps and pure, bright colours. By John of Patmos and his contemporaries walls of glass were conceivable only in the New Jerusalem. Today they are

a feature of every up-to-date office building and bungalow. And this glut of glass has been paralleled by a glut of chrome and nickel, of stainless steel and aluminium and a host of alloys old and new. Metal surfaces wink at us in the bathroom, shine from the kitchen sink, go glittering across country in cars and trains. Those rich convex reflections ... are now the commonplaces of home and street and factory. The fine point of seldom pleasure has been blunted. What was once a needle of visionary delight has now become a piece of disregarded linoleum.

Huxley, of course, had a problem with his brave new industrial present. For all its brilliance, the *Doors of Perception* only opened onto a library and back garden in the country. Huxley's visions were protected from the vulgarities of Woolworth's, modern bungalows and old lino. The insistent colours of the street would have killed the delicate intensity of his hallucinogenic tulips. But Huxley was far from alone in his anxiety that colour, though potentially liberating, had also been contaminated by industry and mass culture. Or that unsophisticated people had destroyed the refinements and subtleties of colour through their crude, almost instinctual attraction to bright hues and shiny finishes. It was the same for Le Corbusier. And for Des Esseintes, who was involved in a constant battle to salvage something of colour from shopkeepers, butchers' wives and the rest of the common mass of people. Baudelaire, too, remarked that according to Pascal, 'togas, purple, and plumes have been most happy inventions to impress the vulgar herd . . .'[10] Walker Evans, the great monochromatic photographer, considered colour photography a 'vulgar' medium. He also thought of colour as something that came up from the streets, discordantly and incoherently: '. . . colour photographers confuse colour with noise,' they '[blow] you down with screeching hues alone . . . a bebop of electric blues, furious reds and poison greens'.[11] More recently, the American painter Peter Halley was reported as saying that 'over the

last few years he has felt a bit out in the cold because of what he recognises as a general art world aversion to painting. But also because maybe collectors and critics find his colours too working-class. They think muted colours are more tasteful.'[12]

Finally, there is Goethe, in his *Theory of Colours* at the end of a particularly strange discussion of 'Pathological Colours':

> . . . it is also worthy of remark, that savage nations, uneducated people, and children have a great predilection for vivid colours; that animals are excited to rage by certain colours; that people of refinement avoid vivid colours in their dress and the objects that are about them, and seem inclined to banish them altogether from their presence.[13]

That passage was written during the first decade of the nineteenth century, yet it brings us back to exactly the place where we began. Back to the cold light of refinement, back to a world banished of colour and all that comes with it, back to a rageless, fleshless, colourless whiteness. Back to the late twentieth-century whited sepulchre where the illusion of culture without corruption can be acted out as if it were real.

References

When a source is cited several times in the same chapter, I have included all citations in a single reference.

One: Whitescapes

1 Herman Melville, *Moby Dick or The Whale* (London, 1992), p. 212. Subsequent quotations are from pp. 205, 212.

2 Joseph Conrad, *Heart of Darkness* (Oxford, 1990), p. 145. Subsequent quotations are from pp. 145–6, 209, 212, 230.

3 Matthew 23:27–8; Conrad, *Heart of Darkness*, p. 266.

4 Walter Pater, *The Renaissance* (London, 1961), p. 205.

5 Quoted in Alex Potts, *Flesh and the Ideal* (New Haven and London, 1994), p. 164.

6 Martin Jay, *Downcast Eyes: The Denigration of Vision in Twentieth-Century French Thought* (Berkeley, Los Angeles and London, 1993), p. 26.

7 Mikhail Bakhtin, *Rabelais and His World*, trans. H. Iswolsky (Bloomington, 1984), p. 320.

8 Isaiah 1:18.

9 Henri Michaux, 'With Mescaline', in *Darkness Moves: An Henri Michaux Anthology 1927–1984*, trans. D. Ball (Berkeley and London, 1994), p. 198.

Two: Chromophobia

1 Charles Blanc, quoted in Charles A. Riley II, *Color Codes* (Hanover and London, 1995), p. 6.

2 Charles Blanc, *The Grammar of Painting and Engraving*, trans. K. Newell Doggett (New York, 1874), p. 1. Subsequent quotations are from pp. 3–5, 70, 98, 111, 145–7, 166–9.

3 Aristotle, quoted in Jacqueline Lichtenstein, *The Eloquence of Color: Rhetoric and Painting in the French Classical Age*, trans. E. McVarish (Berkeley, 1993), p. 59.

4 John Gage, *Colour and Culture* (London, 1993), p. 10.

5 Jean-Jacques Rousseau, *Discourses and Essay on the Origins of Language*, trans. Victor Gourevitch (New York, 1986), pp. 239–94, 279.

6 Joshua Reynolds, 'Discourse IV', in *Discourses*, ed. Pat Rogers (London, 1992), p. 129.

7 Bernard Berenson, *Aesthetics and History* (London, 1950), p. 76.

8 See Lichtenstein, *The Eloquence of Color*, p. 54; Riley, *Color Codes*, p. 20.

9 Roland Barthes, 'Cy Twombly, Works on Paper', in *The Responsibility of Forms: Critical Essays on Music, Art, and Representation* (Oxford, 1986), pp. 157–76, here p. 166.

10 Aldous Huxley, *The Doors of Perception* (London, 1994), p. 6. Subsequent quotations are from pp. 6, 7, 9, 13, 15, 35.

11 Marion Milner, *On Not Being Able to Paint* (London, 1971), p. 25.

12 Paul Smith, *Interpreting Cézanne* (London, 1996), p. 48.

13 Gustave Moreau, quoted in Roger Benjamin, *Matisse's 'Notes of a Painter': Criticism, Theory, and Context, 1891–1908* (Ann Arbor, 1987), p. 29.

14 Charles Baudelaire, 'The Life and Work of Eugène Delacroix', in *Baudelaire: Selected Writings on Art and Artists*, trans. P. E. Chavert (Cambridge, 1972), pp. 358–89, here p. 365.

15 Salman Rushdie, *The Wizard of Oz* (London, 1992), p. 16.

16 Le Corbusier, *Journey to the East*, trans. I. Žaknić (Cambridge, MA, 1987), p. 19. Subsequent quotations are from pp. 14, 16, 20, 24, 25, 26, 36, 110, 140, 177, 203, 207, 209–12, 216, 230.

17 Le Corbusier, *The Decorative Art of Today*, in *Essential Le Corbusier: L'Esprit Nouveau Articles*, trans. J. Dunnett (Oxford, 1998), p. 135.

18 Adolf Loos, 'Ornament and Crime', in *The Architecture of Adolf Loos*, trans. W. Wang (London, 1985), p. 168.

19 Theo van Doesburg, quoted in Mark Widgley, *White Walls, Designer Dresses: The Fashioning of Modern Architecture* (Cambridge, MA, and London, 1995), p. 239.

20 Le Corbusier and Amédée Ozenfant, 'Purism', in *Modern Artists on Art: Ten Unabridged Essays*, ed. R. L. Herbert (New Brunswick, NJ, 1964), pp. 67, 70. Subsequent quotations are from pp. 67–71.

Three: Apocalypstick

1 Roland Barthes, *Camera Lucida: Reflections on Photography* (London, 1982), p. 81.

2 Immanuel Kant, *Critique of Aesthetic Judgement*, trans. J. C. Meredith (Oxford, 1952), p. 67.

3 J.-D. Ingres, quoted in Adrian Stokes, *Colour and Form* (London, 1950), p. 121.

4 Quoted in Jacqueline Lichtenstein, *The Eloquence of Color: Rhetoric and Painting in the French Classical Age*, trans. E. McVarish (Berkeley, 1993), p. 38.

5 Charles Baudelaire, 'The Painter of Modern Life', in *Baudelaire: Selected Writings on Art and Artists*, trans. P. E. Charvet (Cambridge, 1972), pp. 390–435, here p. 425. Subsequent quotation is from p. 369.

6 Roland Barthes, *Roland Barthes by Roland Barthes* (Berkeley, 1994), p. 143.

7 Joris-Karl Huysmans, *Against Nature*, trans. R. Baldrick (London, 1959), p. 25. Subsequent quotations are from pp. 17, 25, 28, 40, 43, 53, 55, 96–7, 98, 99, 101–2, 105, 106, 111.

8 Roland Barthes, 'That Old Thing, Art', in *The Responsibility of Forms: Critical Essays on Music, Art, and Representation*, trans. R. Howard (Oxford, 1986), p. 204.

9 Mandy Merck, 'Figuring Out Warhol', in *Pop Out: Queer Warhol*, ed. Jennifer Doyle, Jonathan Flatley and José Esteban Muñoz (Durham, NC, 1996), pp. 224–37, here p. 232.

10 Charles A. Riley II, *Color Codes* (Hanover and London, 1995), p. 6.

11 Derek Jarman, *Chroma* (London, 1993), p. 58.

12 Edwin A. Abbott, *Flatland: A Parable of Spiritual Dimensions* (Oxford, 1994), pp. 52–3. Subsequent quotations are from pp. 54, 56, 57, 64, 65.

13 *Guardian*, 18 June 1999, p. 10.

14 *Guardian*, 8 September 1999, p. 3.

15 Barthes, *Roland Barthes by Roland Barthes*, p. 143.

Four: Hanunoo

1 Le Corbusier, *Journey to the East*, trans. I. Žaknić (Cambridge, MA, 1987), p. 138.

2 Bernard Berenson, *Aesthetics and History* (London, 1950), p. 75.

3 Aldous Huxley, *The Doors of Perception* (London, 1994), p. 9.

4 Roland Barthes, 'Cy Twombly: Works on Paper', in *The Responsibility of Forms: Critical Essays on Music, Art, and Representation*, trans. R. Howard (Oxford, 1986), p. 166.

5 Aldous Huxley, *Heaven and Hell* (London, 1994), p. 72. Subsequent quotations are from pp. 61, 65–8, 73, 74, 75, 78, 83.

6 Yves Klein, quoted in Sidra Stich, *Yves Klein*, exh. cat., Museum Ludwig, Cologne, Hayward Gallery, London, and Museo Nacional Centro de Arte Reina Sophia, Madrid (London, 1995), p. 50. Subsequent quotations are from pp. 49–51.

7 Charles Baudelaire, 'The Painter of Modern Life', in *Baudelaire: Selected Writings on Art and Artists*, trans. P. E. Charvet (Cambridge, 1972), pp. 390–435, here p. 398.

8 Dave Hickey, 'Pontormo's Rainbow', in *Air Guitar: Essays on Art and Democracy* (Los Angeles, 1997), p. 48.

9 Elizabeth Barrett Browning, *Sonnets from the Portuguese*.

10 Faber Birren, *Color and Human Response* (New York and London, 1978), p. 117.

11 Søren Kierkegaard, quoted in Charles A. Riley II, *Color Codes* (Hanover and London, 1995), p. 17.

12 John Gage, *Colour and Culture* (London, 1993), p. 10.

13 Riley, *Color Codes*, p. 12.

14 Stephen Melville, 'Colour Has Not Yet Been Named: Objectivity in Deconstruction', in *Seams: Art as Philosophical Context – Essays by Stephen Melville*, ed. Jeremy Gilbert Rolfe (Amsterdam, 1996), pp. 127–46, here p. 141.

15 Leonard Shalin, quoted in Riley, *Color Codes*, p. 6.

16 Julia Kristeva, 'Giotto's Joy', in *Desire in Language*, trans. T. Gora, A. Jardine and L. S. Roudiez (Oxford, 1982), p. 216. Subsequent quotations are from pp. 216, 220, 221.

17 Jacqueline Lichtenstein, *The Eloquence of Color: Rhetoric and Painting in the French Classical Age*, trans. E. McVarish (Berkeley, 1993), p. 194.

18 Plotinus, quoted in Gage, *Colour and Culture*, p. 14.

19 See John Lyons, 'Colour and Language', in *Colour: Art and Science*, ed. T. Lamb and J. Bourriau (Cambridge, 1995), pp. 194–224.

20 Derek Jarman, *Chroma* (London, 1994), p. 94.

21 *Ibid.*, p. 140.

22 *Ibid.*, p. 141.

23 Ludwig Wittgenstein, *Remarks on Colour*, trans. G. E. M. Anscombe (Oxford, 1977), pp. 36, 37.

24 Adrian Stokes, *Colour and Form* (London, 1950), p. 28.

25 Umberto Eco, 'How Culture Conditions the Colours We See', in *On Signs*, ed. Marshall Blonsky (Oxford, 1985), pp. 157–74, here p. 173.

26 See C. L. Hardin, *Color for Philosophers: Unweaving the Rainbow* (Indianapolis, 1988), pp. 155–65.

27 Ludwig Wittgenstein, *Philosophical Investigations*, trans. G. E. M. Anscombe (Oxford, 1982), p. 117.

28 William Gass, *On Being Blue: A Philosophical Inquiry* (Boston, 1976), p. 34.

29 Arthur Rimbaud, *A Season in Hell*, trans. Patricia Roseberry (Harrogate, 1995), p. 56

30 Isaac Newton, quoted in Longair, 'Light and Colour', pp. 65–102, here p. 72.

31 Gass, *On Being Blue*, pp. 73–4; Melville, 'Colour Has Not Yet Been Named', p. 142.

Five: Chromophilia

1 Frank Stella, 'Questions to Stella and Judd', reprinted in Gregory Battcock, ed., *Minimal Art: A Critical Anthology* (New York, 1968), p. 157.

2 Theodor Adorno, quoted in Jeff Wall, '"Marks of Indifference": Photography in, or as Conceptual Art', in Ann Goldstein and Anne Rorimer, eds, *Reconsidering the Object of Art: 1965–1975*, exh. cat., Museum of Contemporary Art, Los Angeles (Cambridge, MA, 1995), p. 262.

3 Simon Dentith, *Bakhtinian Thought* (London and New York, 1995), p. 66.

4 Charles Baudelaire, 'Of the Essence of Laughter, and Generally of the Comic in the Plastic Arts', in *Baudelaire: Selected Writings on Art and Artists*, trans. P. E. Chavert (Cambridge, 1972), pp. 140–61, here p. 143; Mikhail Bakhtin, *Rabelais and His World*, trans. H. Iswolsky (Bloomington, 1984), p. 89.

5 Julia Kristeva, 'Giotto's Joy', in *Desire in Language*, trans. T. Gora, A. Jardine and L. S. Roudiez (Oxford, 1982), p. 224.

6 Donald Judd, 'Some Aspects of Color in General and Red and Black in Particular', *Artforum*, XXXII/10 (Summer 1994), p. 113.

7 Quoted in Sidra Stich, *Yves Klein*, exh. cat., Museum Ludwig, Cologne, Hayward Gallery, London, and Museo Nacional Centro de Arte Reina Sophia, Madrid (London, 1995), p. 91.

8 Robert Smithson, 'Donald Judd', in *Robert Smithson: Collected Writings*, ed. Jack Flam (Berkeley, 1996), pp. 4–7, here p. 4. The next two quotations are from 'The Crystal Land', pp. 7–9, and 'Entropy and the New Monuments', pp. 10–23, here p. 11.

9 Aldous Huxley, *Heaven and Hell* (London, 1994), pp. 85–6.

10 Charles Baudelaire, 'The Salon of 1859', in *Baudelaire: Selected Writings on Art and Artists*, pp. 285–324, here p. 310.

11 Quoted in Sally Eauclaire, *The New Color Photography* (New York, 1981), p. 9.

12 Quoted in Matthew Collings, *It Hurts* (London, 1998), p. 158.

13 Johann Wolfgang von Goethe, *Theory of Colours*, trans. C. L. Eastlake (Cambridge, MA, and London, 1970), p. 55.

Select Bibliography and Filmography

Abbott, Edwin A., *Flatland: A Parable of Spiritual Dimensions* (Oxford, 1994)

Adorno, Theodor, *Aesthetic Theory*, trans. C. Lenhardt (London and New York, 1984)

Bakhtin, Mikhail, *Rabelais and His World*, trans. Hélène Iswolsky (Bloomington, 1984)

Baudelaire, Charles, *Selected Writings on Art and Artists*, trans. P. E. Charvet (Cambridge, 1972)

Barthes, Roland, *Camera Lucida: Reflections on Photography* (London, 1982)

—, *The Responsibility of Forms: Critical Essays on Music, Art, and Representation*, trans. R. Howard (Oxford, 1986)

—, *Roland Barthes by Roland Barthes* (Berkeley, 1994)

Batchelor, David, 'Colour and the Monochrome', in *Adrian Schiess*, exh. cat., The Showroom, London (1993)

—, 'Chromophobia' (brochure), Henry Moore Institute, Leeds (1995)

—, 'Of Cans, Colour, and Corruption', in *Gary Hume*, exh. cat., British Council, London (1999), pp. 21–8

—, 'Once Were Painters', *Art & Language*, exh. cat., Fundació Antoni Tàpies, Barcelona (1999), vol. 2, pp. 177–83

—, 'The Spectrum, and Other Colors', in *Ellsworth Kelly*, exh. cat., Mitchel-Innes and Nash, New York (1999)

Baum, Frank L, 'The Wizard of Oz', in *The Wonderful World of Oz* (London, 1998), pp. 1–105

Benjamin, Roger, *Matisse's 'Notes of a Painter': Criticism, Theory and Context 1891–1908* (Ann Arbor, 1987)

Berenson, Bernard, *Aesthetics and History* (London, 1950)

Birren, Faber, *Color and Human Response* (New York and London, 1978)

Blanc, Charles, *The Grammar of Painting and Engraving*, trans. Kate Newell Doggett (New York, 1874)

Conrad, Joseph, *Heart of Darkness* (Oxford and New York, 1990)

Dentith, Simon, *Bakhtinian Thought* (London and New York, 1995)

Eco, Umberto, 'How Culture Conditions the Colours We See', in *On Signs*, ed. M. Blonsky (London, 1985), pp. 157–75

Gage, John, *Colour and Culture* (London, 1993)

Gass, William, *On Being Blue: A Philosophical Inquiry* (Boston, 1976)

Glaser, Bruce, 'Questions to Stella and Judd', in G. Battcock, ed., *Minimal Art: A Critical Anthology* (New York, 1968), pp. 148–64

Goethe, Johann Wolfgang von, *Theory of Colours*, trans. C. L. Eastlake (Cambridge, MA, and London, 1970)

Hardin, C. L., *Color for Philosophers: Unweaving the Rainbow* (Indianapolis, 1988)

Hickey, Dave, 'Pontormo's Rainbow', in *Air Guitar: Essays on Art and Democracy* (Los Angeles, 1997)

Huxley, Aldous, *The Doors of Perception* and *Heaven and Hell* (London, 1994)

Huysmans, Joris-Karl, *Against Nature*, trans. Robert Baldrick (London, 1959)

Jarman, Derek, *Chroma* (London, 1994)

Jay, Martin, *Downcast Eyes: The Denigration of Vision in Twentieth-Century French Thought* (Berkeley, Los Angeles and London 1993)

Judd, Donald, 'Some Aspects of Color in General and Red and Black in Particular', *Artforum*, XXXII/10 (Summer 1994), pp. 70–78, 110, 113

Kant, Immanuel, *Critique of Aesthetic Judgement*, trans. J. C. Meredith (Oxford, 1952)

Kristeva, Julia, 'Giotto's Joy', in *Desire in Language*, trans. J. Gora, A. Jardine and L. S. Roudiez (Oxford, 1982)

Lamb, Trevor, and Janine Bourriau, eds, *Colour: Art and Science* (Cambridge, 1995)

Le Corbusier, *Towards a New Architecture*, trans. F. Etchells (London, 1946)

—, *Journey to the East*, trans. Ivan Žaknić (Cambridge, MA, 1987)

—, *Essential Le Corbusier: L'Esprit Nouveau Articles*, trans. J. Dunnett (Oxford, 1998)

—, and Amédée Ozenfant, 'Purism', in R. L. Herbert, ed., *Modern Artists on Art: Ten Unabridged Essays* (New Brunswick, NJ, 1964)

Lichtenstein, Jacqueline, *The Eloquence of Color: Rhetoric and Painting in the French Classical Age*, trans. E. McVarish (Berkeley, 1993)

Loos, Adolf, 'Ornament and Crime', in *The Architecture of Adolf Loos*, trans. Wilfred Wang (London, 1985)

Melville, Herman, *Moby Dick or The Whale* (London, 1992)

Melville, Stephen, 'Colour Has Not Yet Been Named: Objectivity in Deconstruction', in *Seams: Art as Philosophical Context – Essays by Stephen Melville*, ed. Jeremy Gilbert Rolfe (Amsterdam, 1996), pp. 127–46

Merck, Mandy, 'Figuring Out Warhol', in *Pop Out: Queer Warhol*, ed. Jennifer Doyle, Jonathan Flatley and José Esteban Muñoz (Durham, NC, 1996), pp. 224–37

Milner, Marion, *On Not Being Able to Paint* (London, 1971)

Pater, Walter, *The Renaissance* (London, 1961)

Riley, Charles A. II, *Color Codes* (Hanover and London, 1995)

Rousseau, Jean-Jacques, *Discourses and Essay on the Origins of Language*, trans. Victor Goirevitch (New York, 1986)

Rushdie, Salman, *The Wizard of Oz* (London, 1992)

Smith, Paul, *Interpreting Cézanne* (London, 1996)

Smithson, Robert, *Robert Smithson: Collected Writings*, ed. Jack Flam (Berkeley, 1996)

Stella, Frank, 'Questions to Stella and Judd', reprinted in Gregory Battcock, ed., *Minimal Art: A Critical Anthology* (New York, 1968)

Stich, Sidra, *Yves Klein*, exh. cat., Museum Ludwig, Cologne, Hayward Gallery, London, and Museo Nacional Centro de Arte Reina Sophia, Madrid (London, 1995)

Stokes, Adrian, *Colour and Form* (London, 1950)

Widgley, Mark, *White Walls, Designer Dresses: The Fashioning of Modern Architecture* (Cambridge, MA, and London, 1995)

Wittgenstein, Ludwig, *Remarks on Colour*, trans. G. E. M. Anscombe (Oxford, 1977)

—, *Philosophical Investigations*, trans. G. E. M. Anscombe (Oxford, 1982)

Ivan the Terrible Part II: The Boyars' Plot, dir. Sergei Eisenstein, 1946

Matter of Life and Death, dir. Michael Powell and Emeric Pressburger, 1946

Pleasantville, dir. Gary Ross, 1998

Shock Corridor, dir. Sam Fuller, 1963

Wings of Desire, dir. Wim Wenders, 1986–7

Wizard of Oz, dir. Victor Flemming, 1939

List of Illustrations

pp. 6–7: A coloured transmission electron micrograph (TEM) of the Hepatitis B virus, seen at a magnification of 1 × 64,000. Photo: NIBSC/Science Photo Library.

p. 8: An illustration by A. Burnham Shute from an early edition of Herman Melville's *Moby Dick*.

p. 20: A still from Victor Fleming's 1939 film *The Wizard of Oz*. Photo: Ronald Grant Archive.

p. 50: Andy Warhol, *Do It Yourself* (*Flowers*), 1962, graphite and coloured crayon on paper. Photo: Sonnabend Gallery, New York. © The Andy Warhol Foundation for the Visual Arts, Inc./ARS, NY and DACS, London 2000.

p. 72: 'Ordnung der Farbenclasse', hand-coloured illustration from Ignaz Schiffermüller, *Versuch eines Farbensystems* (Vienna, 1772).

p. 96: Jim Lambie, *ZOBOP*, 1999, vinyl tape, installation at Transmission Gallery, Glasgow, 1999. Photo: courtesy of The Modern Institute, Glasgow/Alan Dimmick.

Acknowledgements

An inquiry into colour can take you just about anywhere. One of the pleasures of working on a book about colour is that almost everyone you meet has read something or seen something, somewhere, that might be relevant. And people, I found, like to talk about colour. The process of following up these often informal suggestions and observations took me far beyond my usual narrow reading and thinking habits and broadened the scope of this book considerably. Special thanks are due to Stephen Batchelor, who commented on the text at different stages, and to Ann Gallagher, who did likewise and more. Many thanks also to Polly Apfelbaum, Stephen Bann, Gina Birch, Iwona Blazwick, Andrew Brighton, Alex Coles, Tacita Dean, Leslie Dick, Steve Edwards, Briony Fer, Bruce Ferguson, Jason Gaiger, Teresa Gleadowe, Rodney Graham, Mathew Hale, Charles Harrison, Alex Hartley, Mathew Higgs, Mike Holdsworth, Lorraine Kisley, Tania Kovats, Alex Landrum, Robert Linsley, Amna Malik, Susan May, Sara Maynard, Kathleen Merrill, Cuatemoc Medina, Mike Murphy, Michael Newman, Richard Noble, Shannon Oksanen, Peter Osborne, Pavel Polit, Alex Potts, Mel Ramsden, David Reed, Al Rees, Olivier Richon, David Robins, Georges Rocque, Lyn Segal, Ingrid Swenson, Eugene Tan, Richard Torchia, Anthony Wilkinson, Dominic Wilsden, Peter Wollen and Paul Wood.

Sections of chapters 2 and 5 appeared in other forms in a number of exhibition catalogues, and the response to these more tentative attempts to write about colour helped a great deal as I developed the current text. So big thanks to Kim Sweet, Penelope Curtis, Clarrie Wallis, Lucy Mitchell-Innes and Art & Language for commissioning the essays 'Colour and the Monochrome' (The Showroom, London, 1993); 'Chromophobia' (Henry Moore Institute, Leeds, 1995); 'On Cans, Colour, and Corruption' (British Pavilion, Venice Biennale, 1999); 'The Spectrum and Other Colours' (Mitchell-Innes and Nash, New York, 1999); and 'Once Were Painters' (Fondació Antoni Tàpies, Barcelona, 1999), respectively. Many thanks also to Andrea Belloli at Reaktion Books for editing this book, to the Research Committee at the Royal College of Art, London, for their financial support, and to many of the students and staff, especially Gillian Campton Smith, Sarah Willcox, Fiona Key and Eugene Rae, who also helped me to complete this project. Lastly, I would like to thank a room: the Colour Library at the RCA, which was an invaluable resource.